VIKTORIYA YAKUBOUSKAYA

FOOD COLORING BOOK

FOR ADULT RELAXATION, CREATIVE HOBBIES AND COOKING

2019

ABOUT

Welcome to my happy and amazing world of color recipe designs!

I created something very special for you - Food Coloring Book For Adult Relaxation... This coloring book contains 40 simple recipes for creativity and cooking - pizza, hummus, chili, paella, salads, soups, fish, meat, pancakes, and more…

My designs will show you the necessary ingredients and cooking processes, so that you can color and then cook... or cook and color. Tasty and fun!

Each design contains both simple and more complex elements. Sometimes you have to guess the ingredient in cooked dishes to color. Turn on the imagination and your inner artist! Play and just see what happens.

BONUS. Unlock More Inspiration!
Scan the QR code to join me on YouTube - **ReStyleGraphic Coloring**. Watch me color pages from this book and learn my favorite techniques for pencils and markers.
Relax. Create. Enjoy.

Viktoriya Yakubouskaya,
Artist

CHICKEN FAJITAS

- Tortillas for serving
- 1 large onion, thinly sliced
- 3 bell peppers, thinly sliced
- 1 lb. skinless chicken breasts
- salt
- black pepper
- 1/2 cup oil
- 1/4 cup lime juice
- 1/2 tsp. red pepper flakes
- 2 tsp. cumin

Cook 5 min

Cook until golden then slice into strips

Marinate 30 min to 2 hours

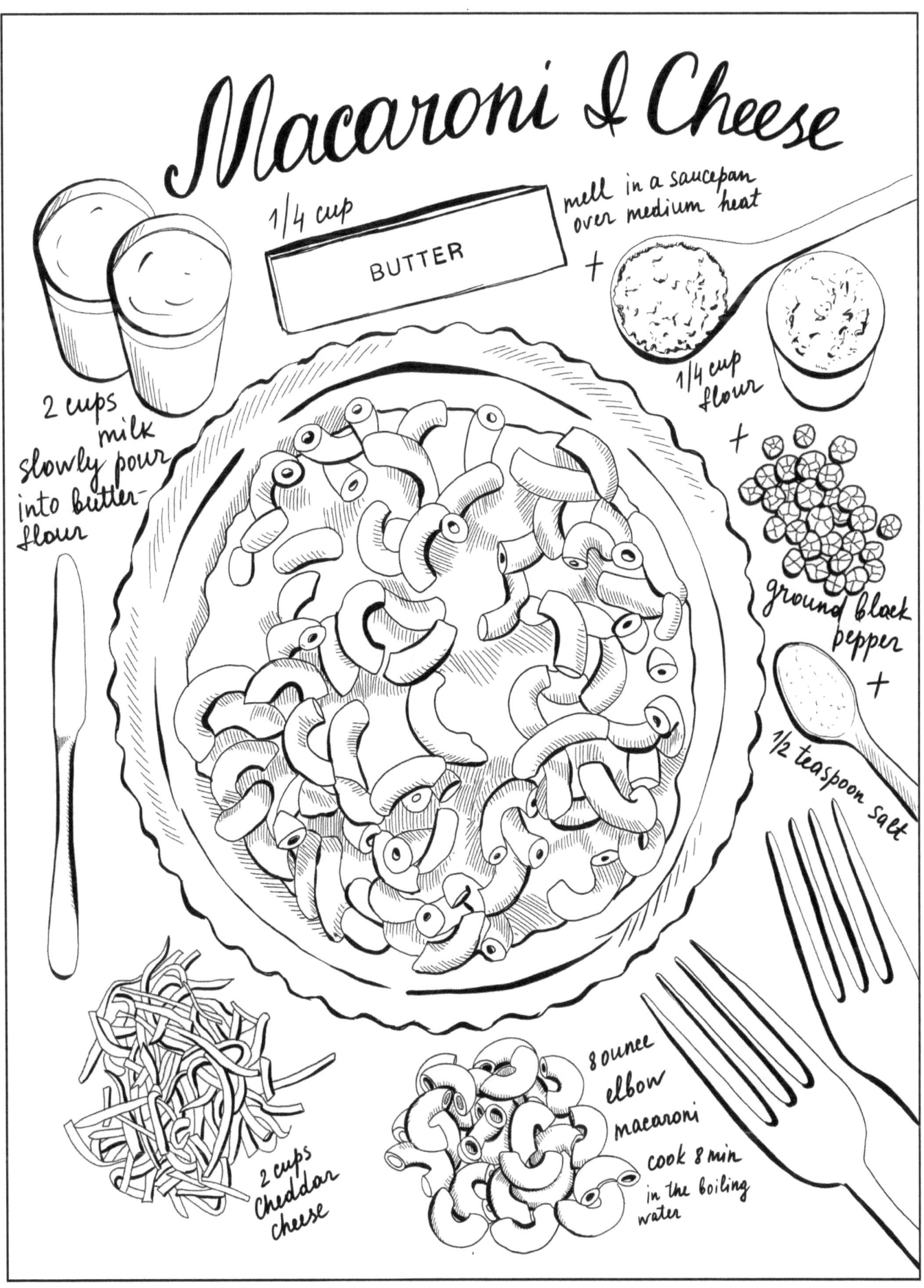

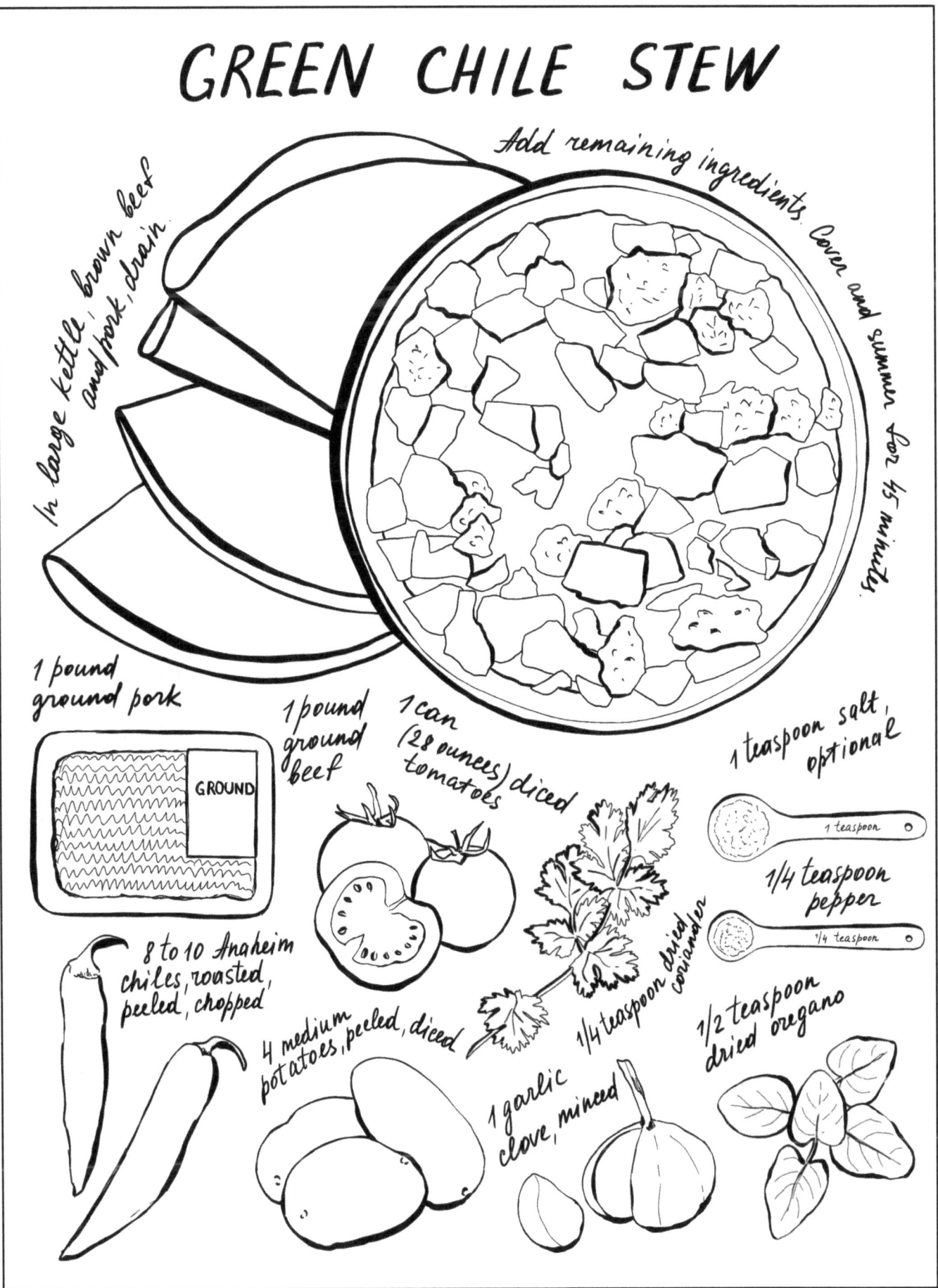

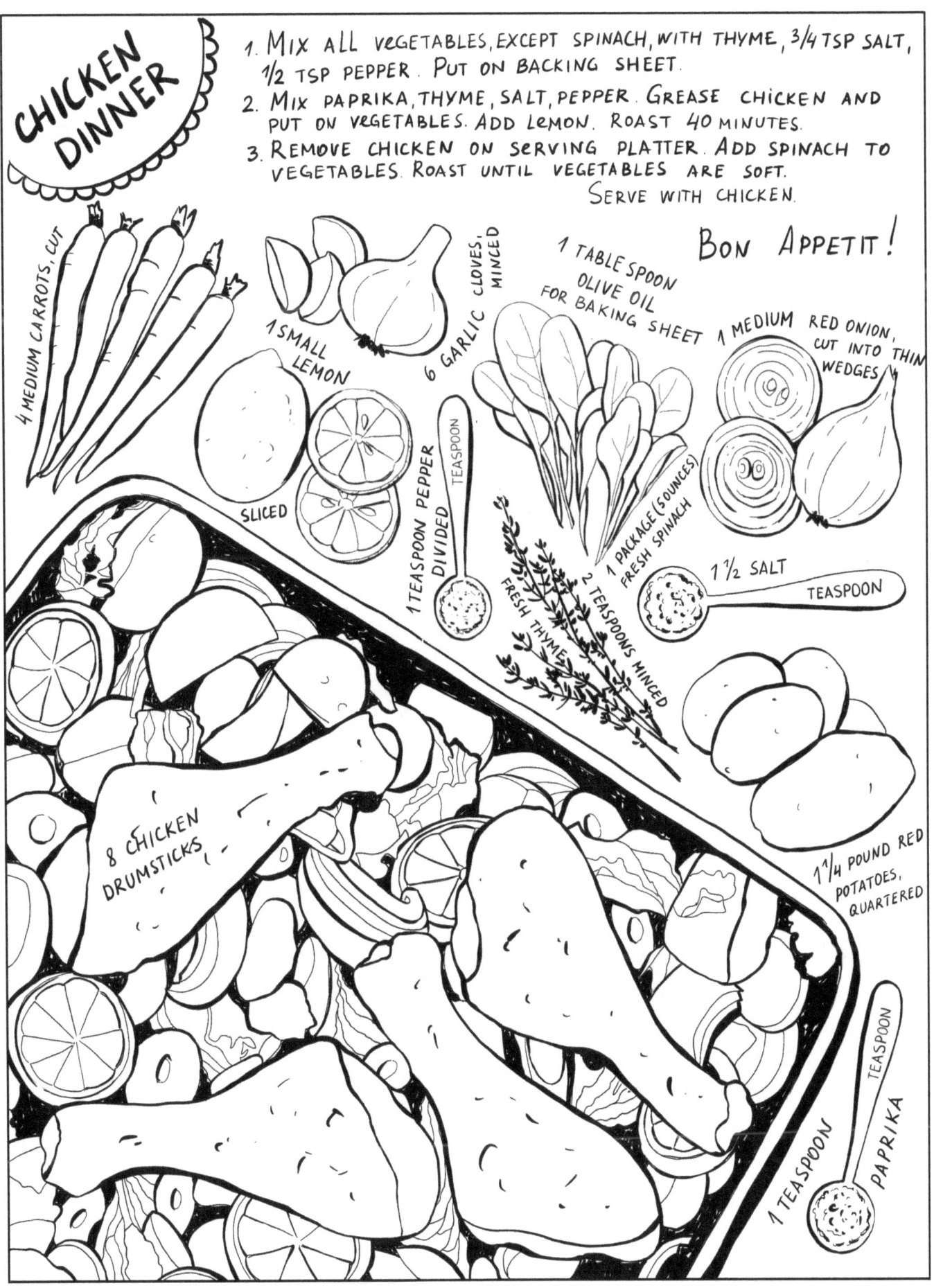

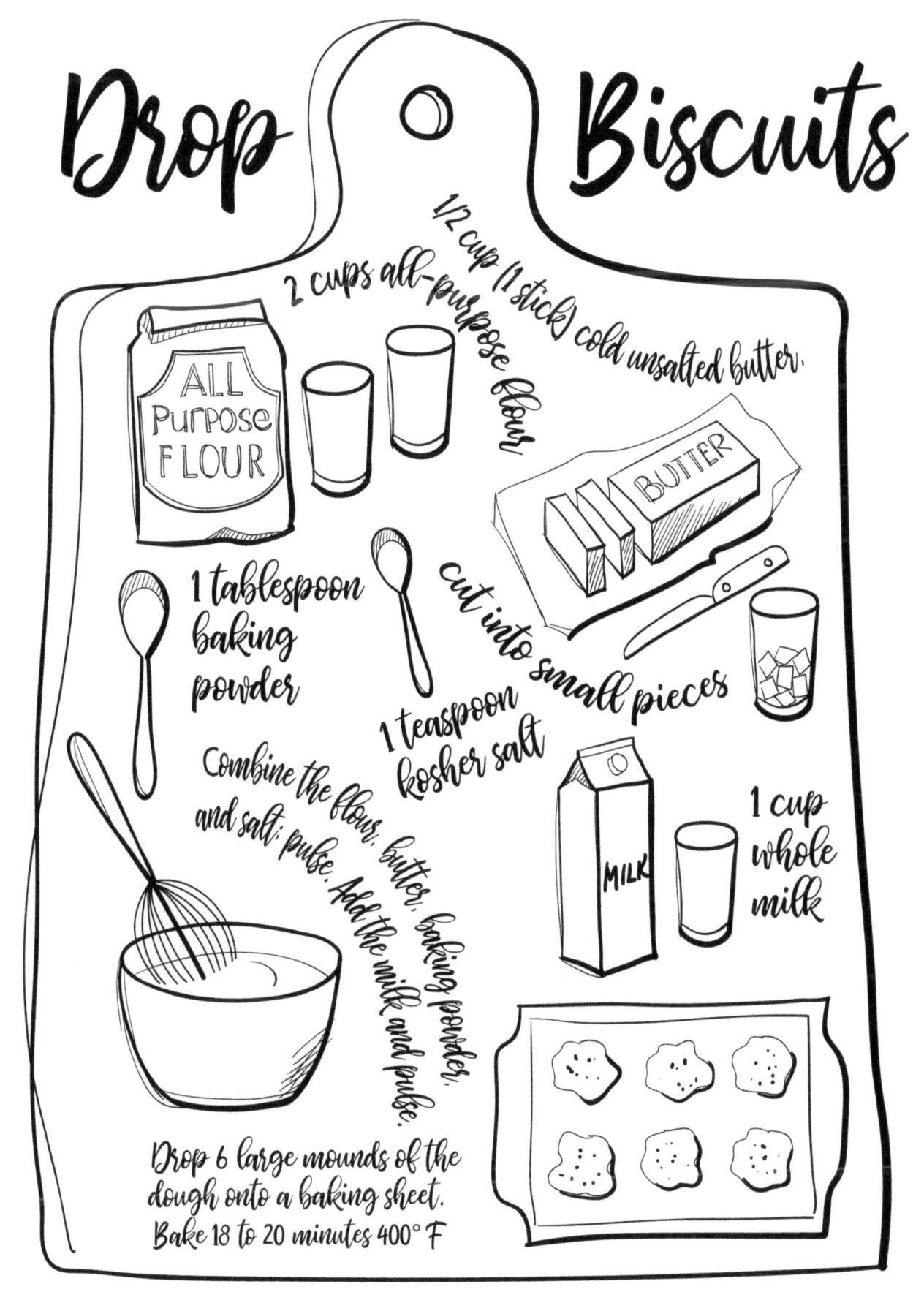

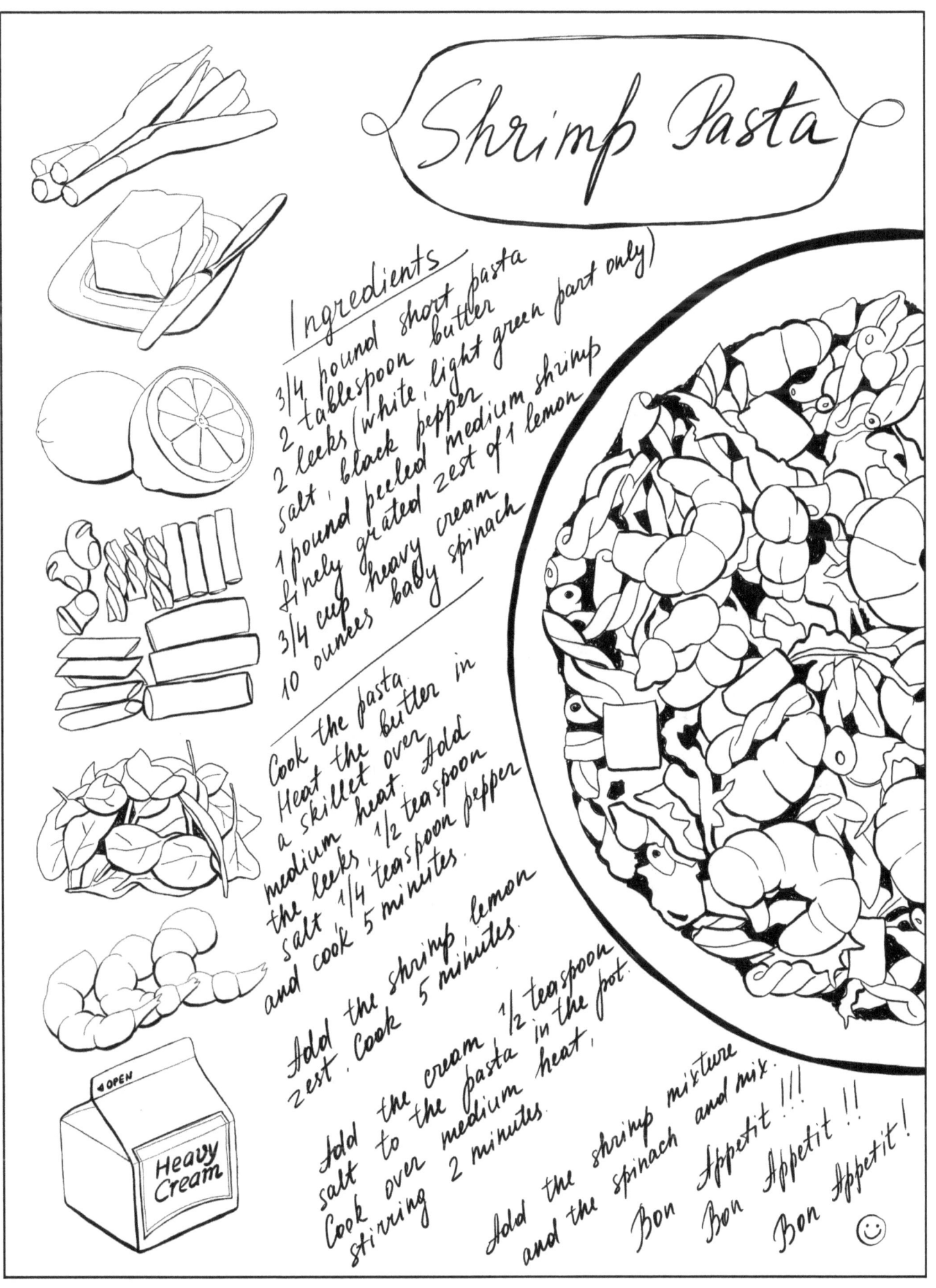

Shrimp Pasta

Ingredients

3/4 pound short pasta
2 tablespoon butter
2 leeks (white, light green part only)
salt, black pepper
1 pound peeled medium shrimp
finely grated zest of 1 lemon
3/4 cup heavy cream
10 ounces baby spinach

Cook the pasta. Heat the butter in a skillet over medium heat. Add the leeks, 1/2 teaspoon salt, 1/4 teaspoon pepper and cook 5 minutes.

Add the shrimp, lemon zest. Cook 5 minutes.

Add the cream, 1/2 teaspoon salt to the pasta in the pot. Cook over medium heat, stirring 2 minutes.

Add the shrimp mixture and the spinach and mix.

Bon Appetit !!!
Bon Appetit !!
Bon Appetit ! ☺

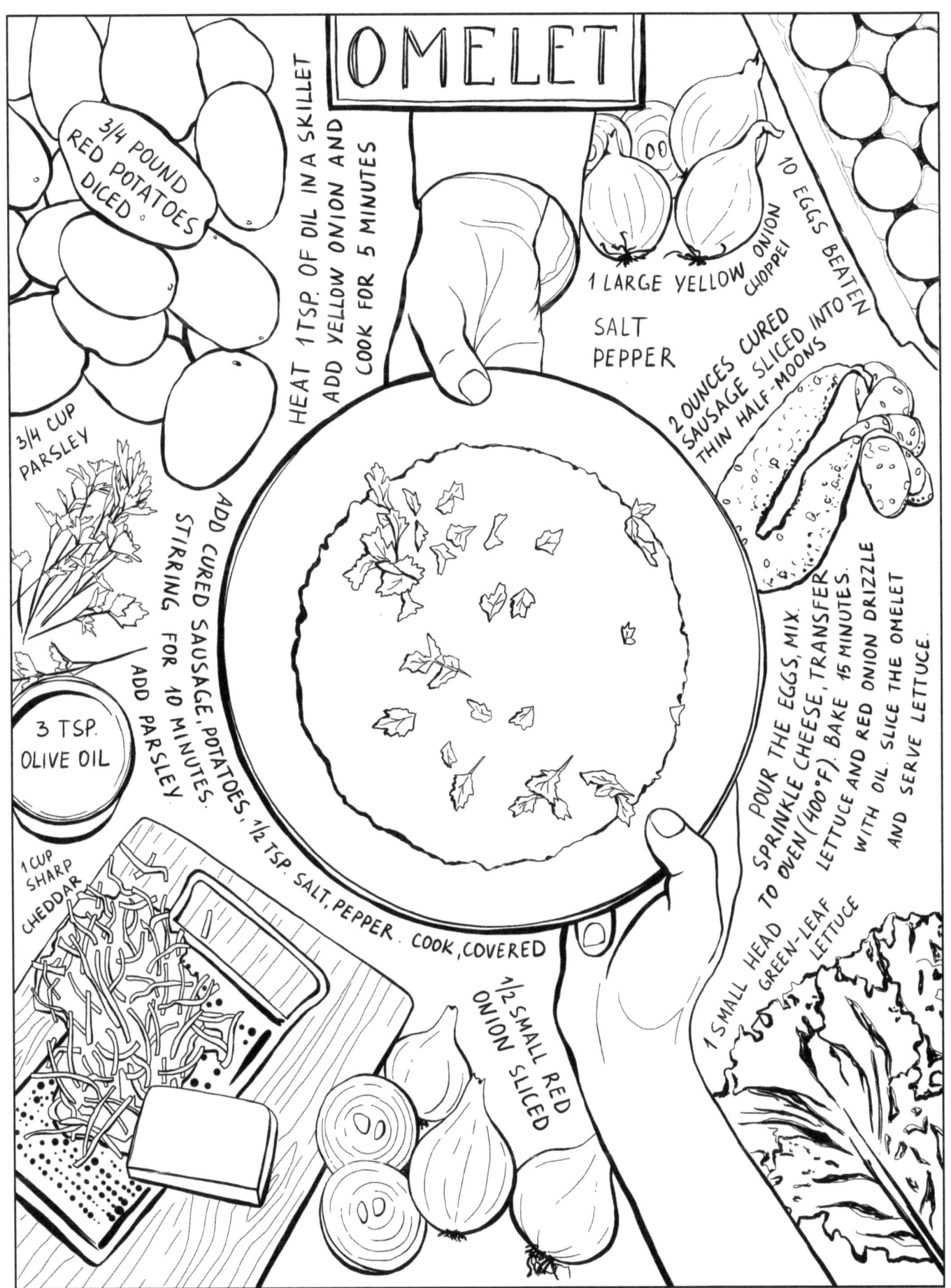

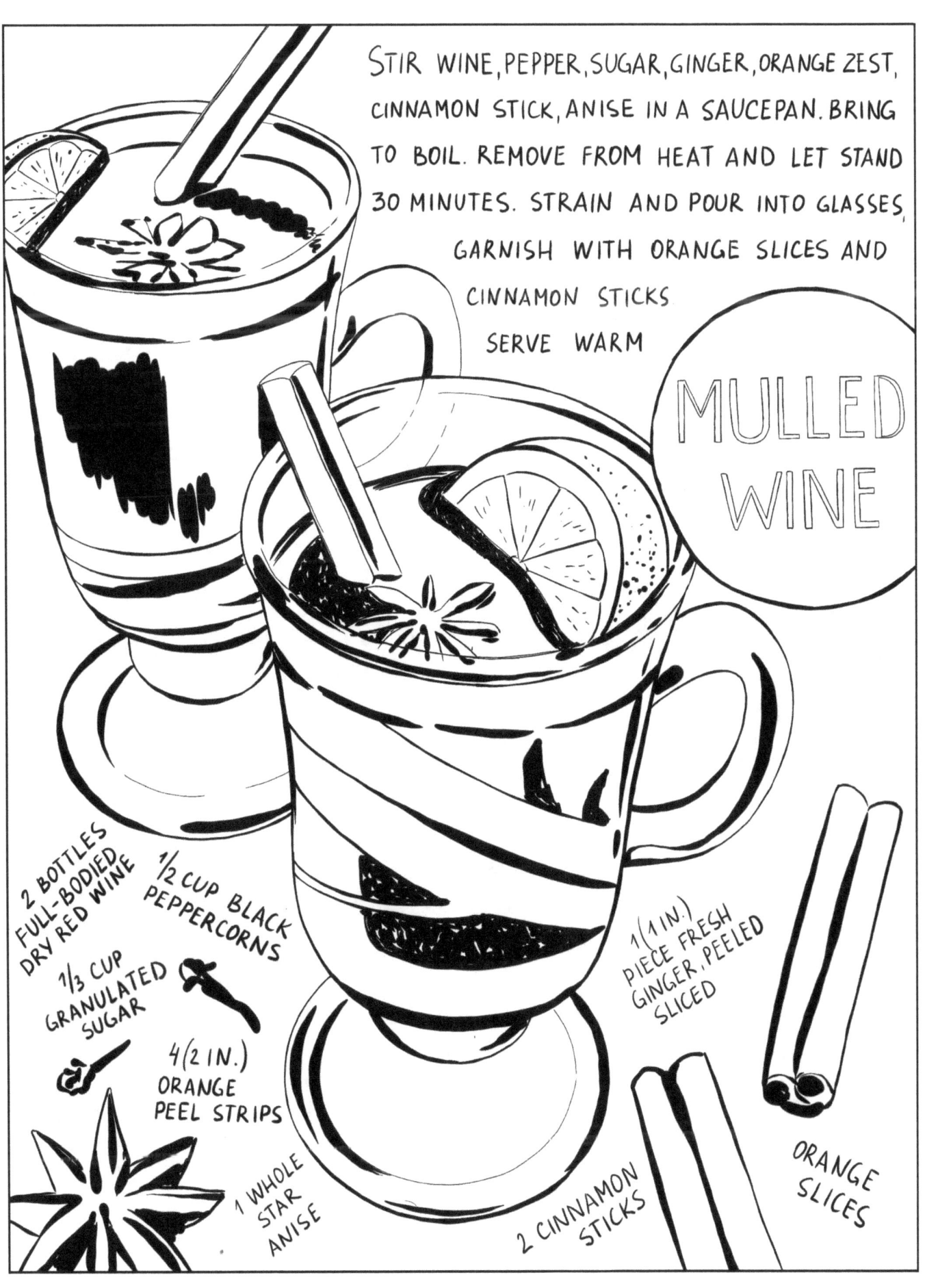

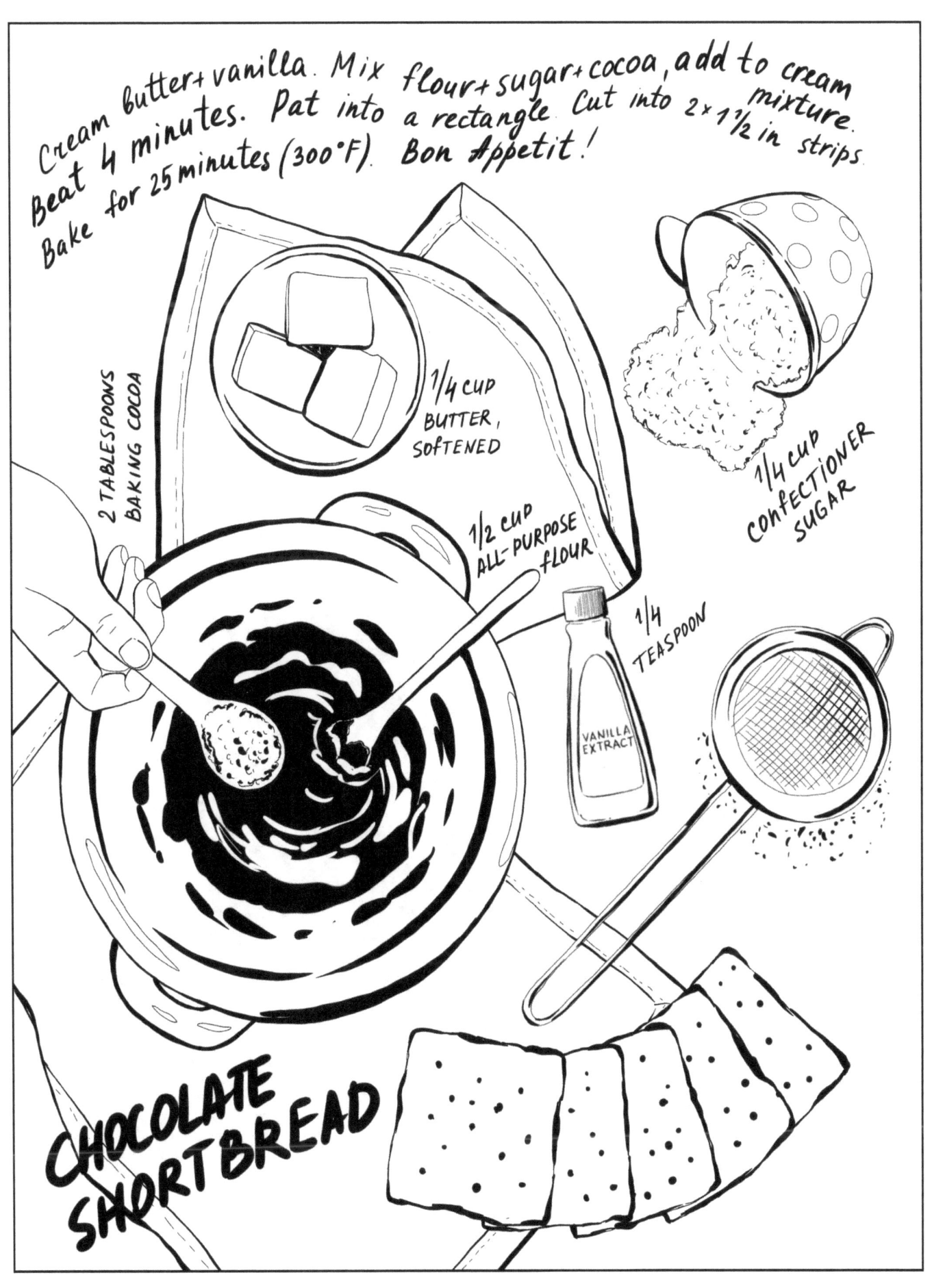

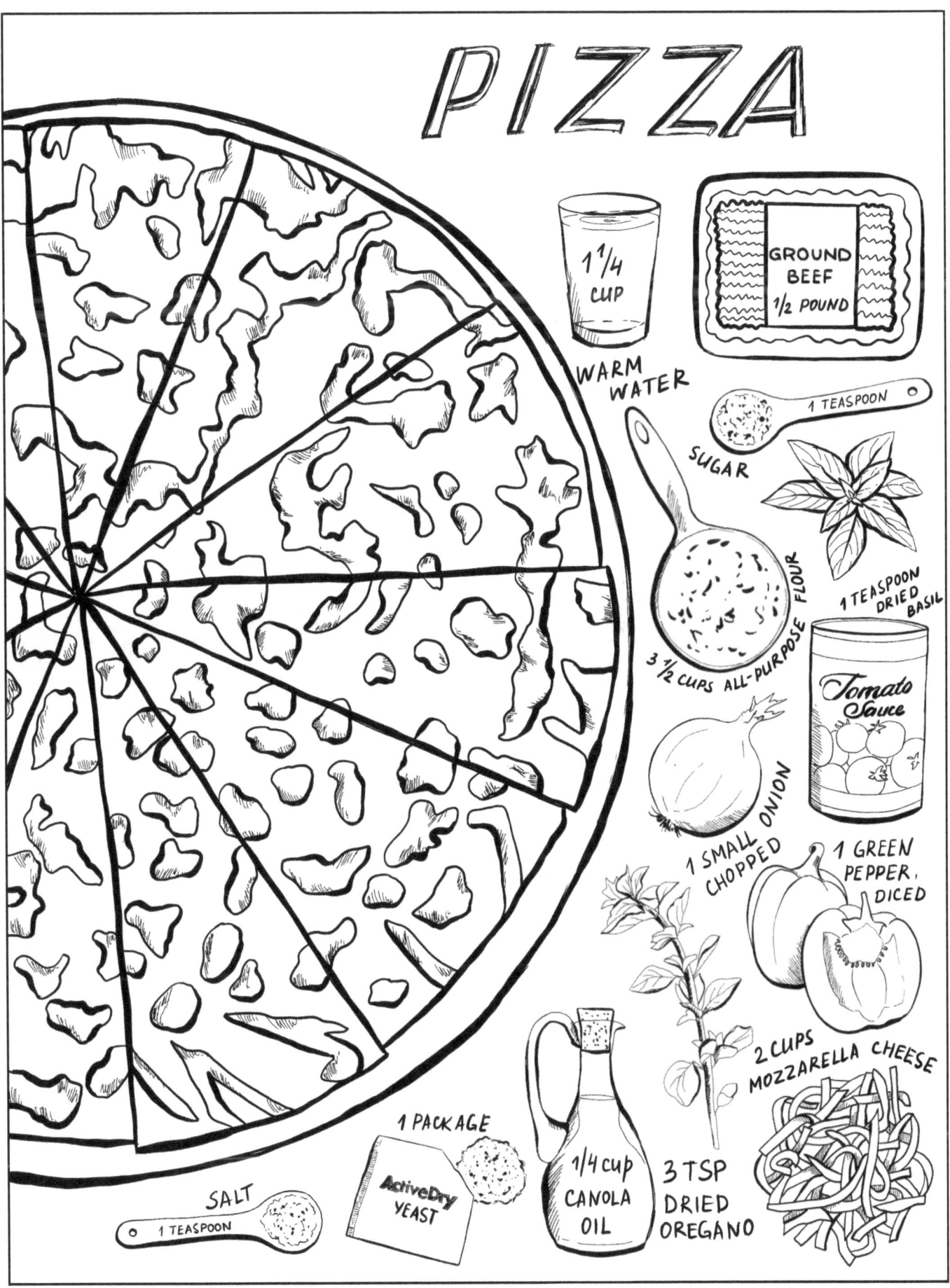

Blueberry-Orange Muffins

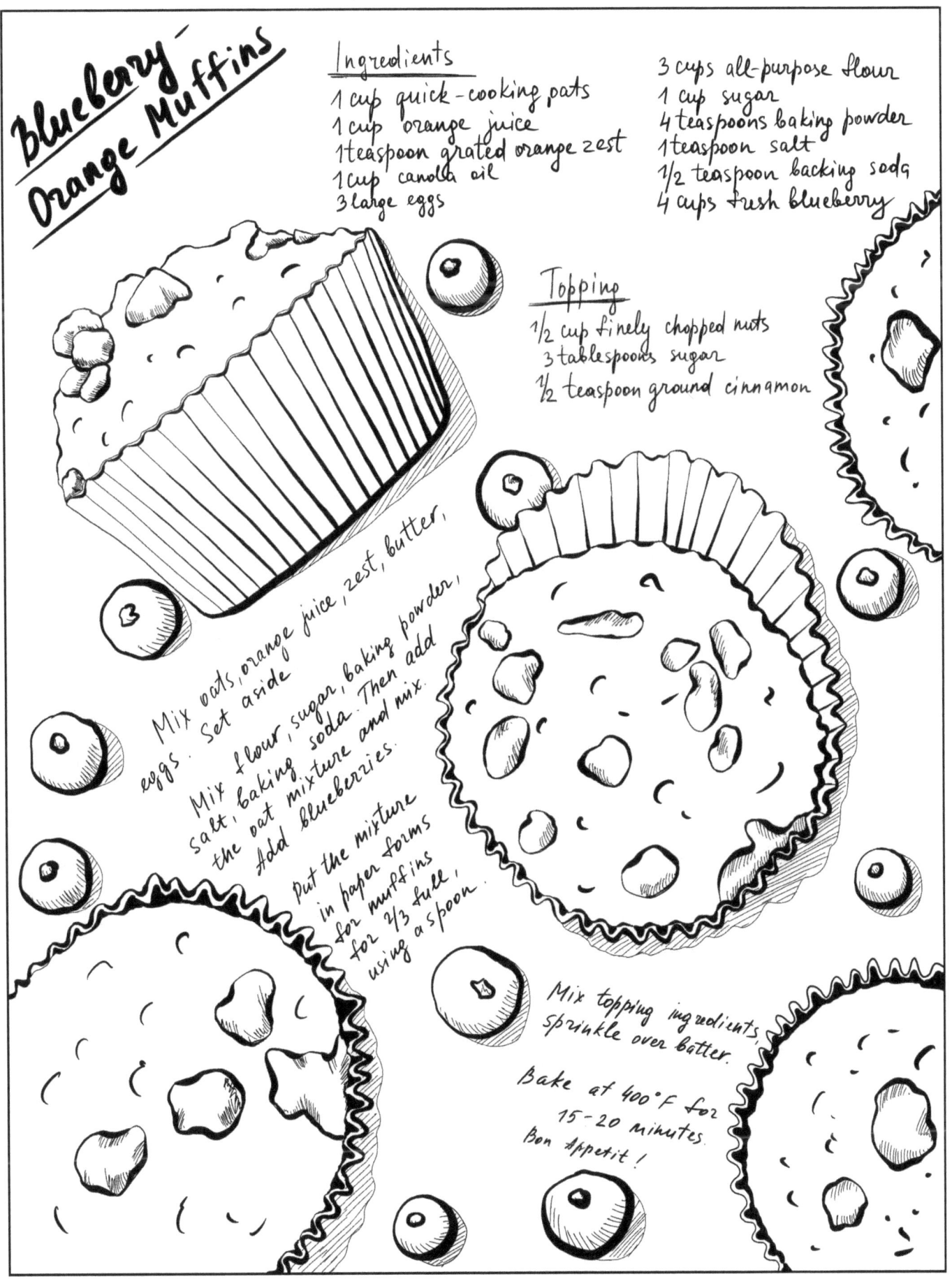

Ingredients
- 1 cup quick-cooking oats
- 1 cup orange juice
- 1 teaspoon grated orange zest
- 1 cup canola oil
- 3 large eggs
- 3 cups all-purpose flour
- 1 cup sugar
- 4 teaspoons baking powder
- 1 teaspoon salt
- 1/2 teaspoon backing soda
- 4 cups fresh blueberry

Topping
- 1/2 cup finely chopped nuts
- 3 tablespoons sugar
- 1/2 teaspoon ground cinnamon

Mix oats, orange juice, zest, butter, eggs. Set aside.

Mix flour, sugar, baking powder, salt, baking soda. Then add the oat mixture and mix. Add blueberries.

Put the mixture in paper forms for muffins for 2/3 full, using a spoon.

Mix topping ingredients, sprinkle over batter.

Bake at 400°F for 15-20 minutes. Bon Appetit!

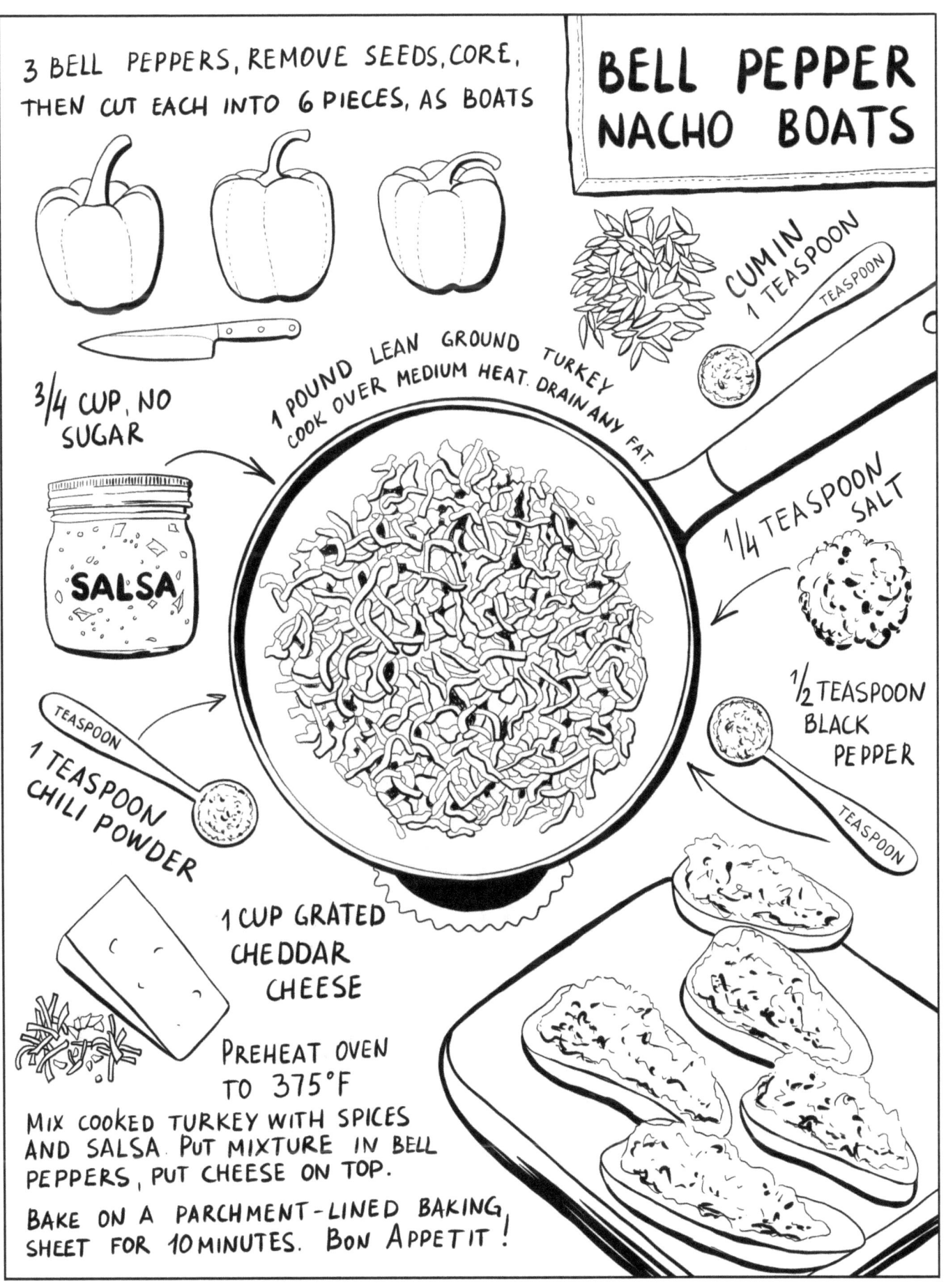

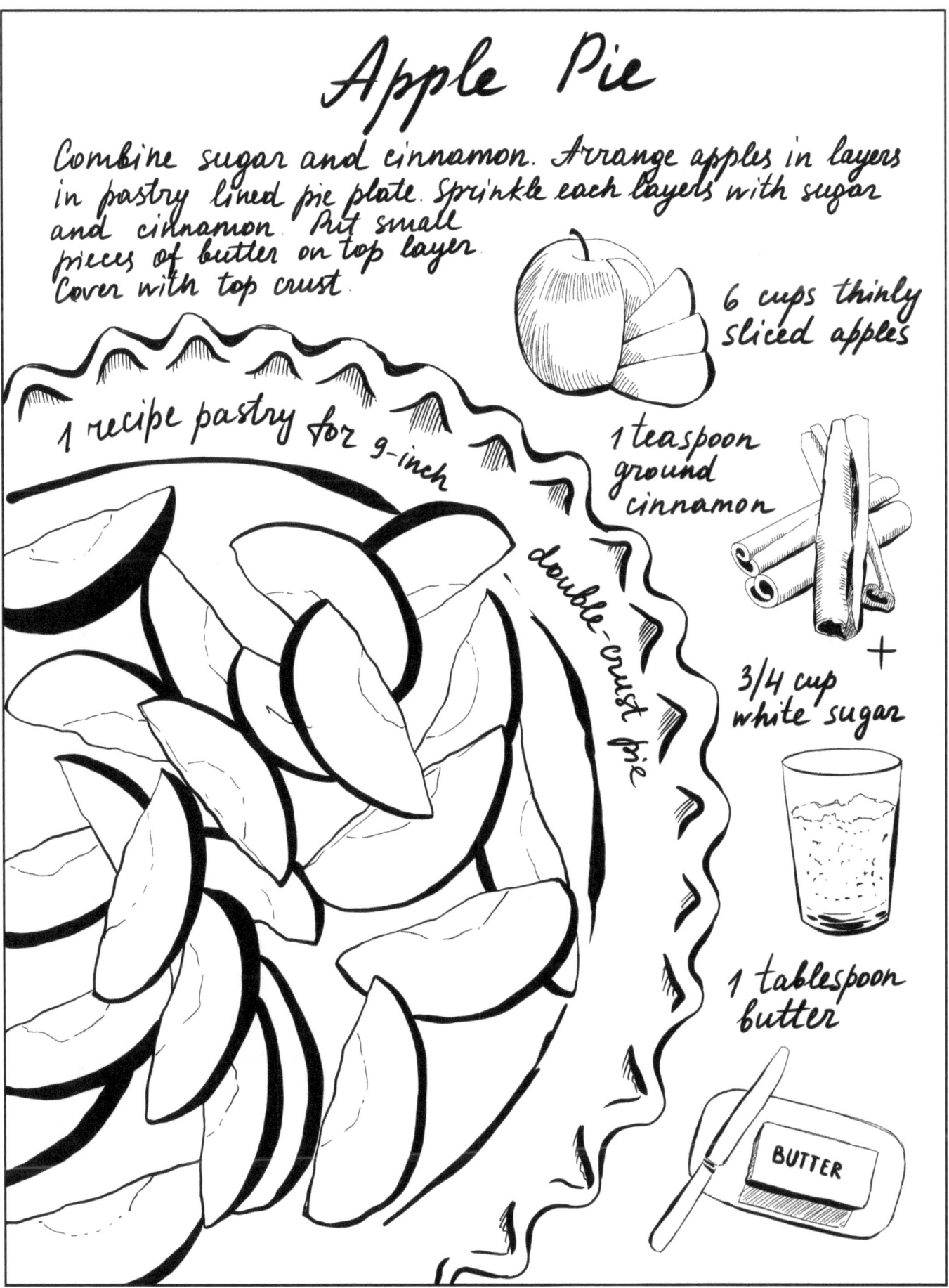

Apple Pie

Combine sugar and cinnamon. Arrange apples in layers in pastry lined pie plate. Sprinkle each layers with sugar and cinnamon. Put small pieces of butter on top layer. Cover with top crust.

- 1 recipe pastry for 9-inch double-crust pie
- 6 cups thinly sliced apples
- 1 teaspoon ground cinnamon
- 3/4 cup white sugar
- 1 tablespoon butter

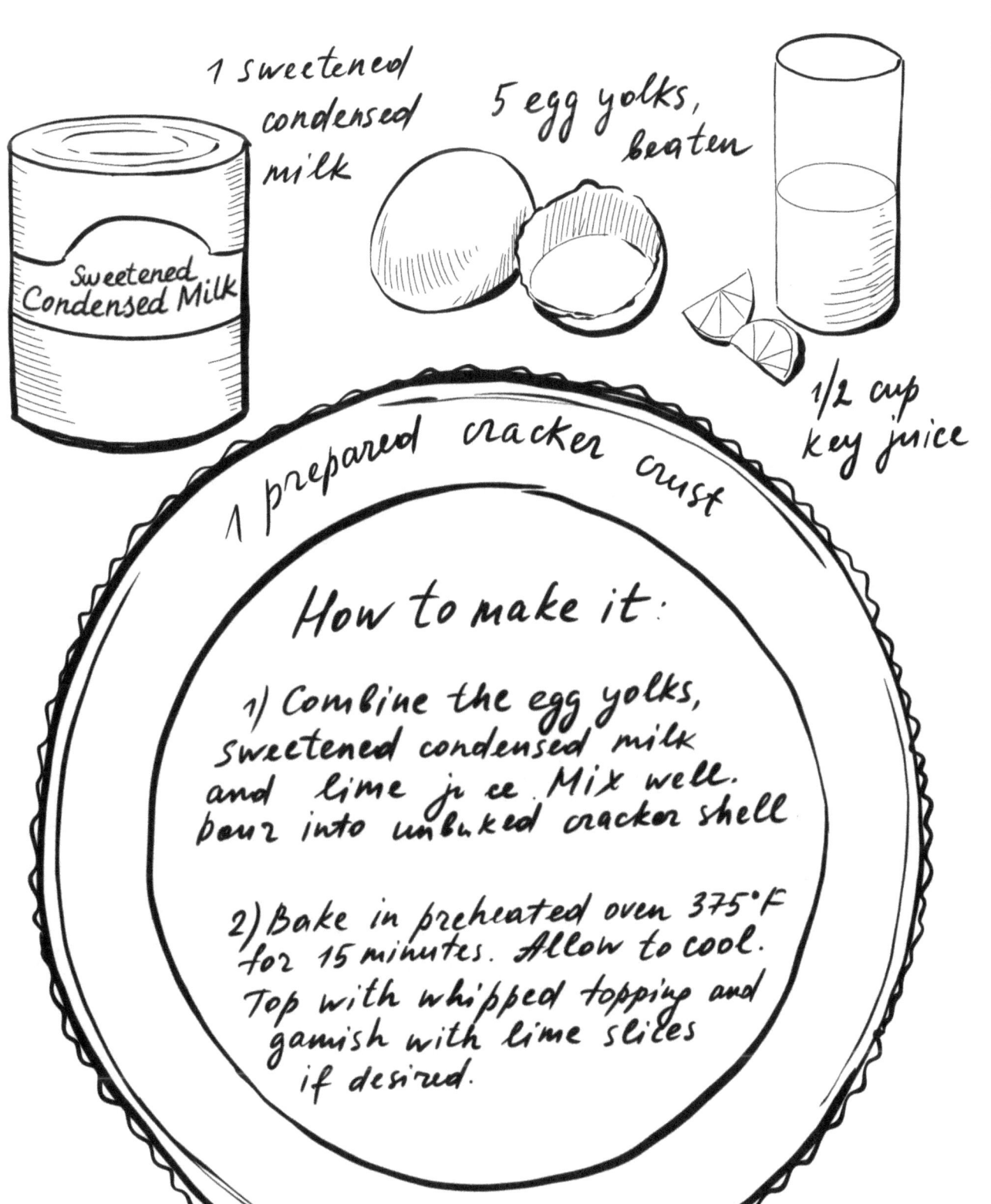

EASY LIME PIE

1 sweetened condensed milk

5 egg yolks, beaten

1/2 cup key juice

1 prepared cracker crust

How to make it:

1) Combine the egg yolks, sweetened condensed milk and lime juice. Mix well. Pour into unbaked cracker shell

2) Bake in preheated oven 375°F for 15 minutes. Allow to cool. Top with whipped topping and garnish with lime slices if desired.

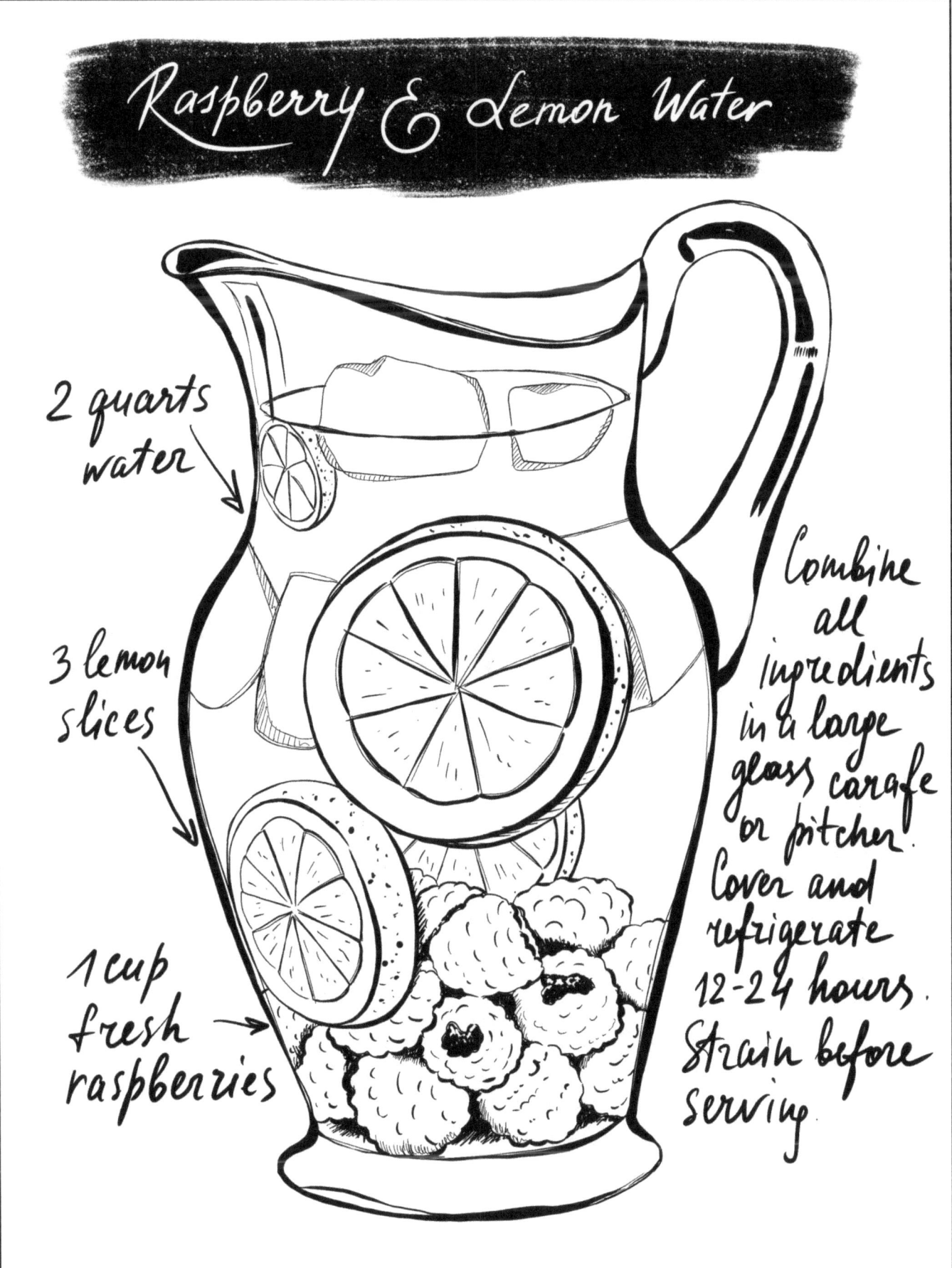

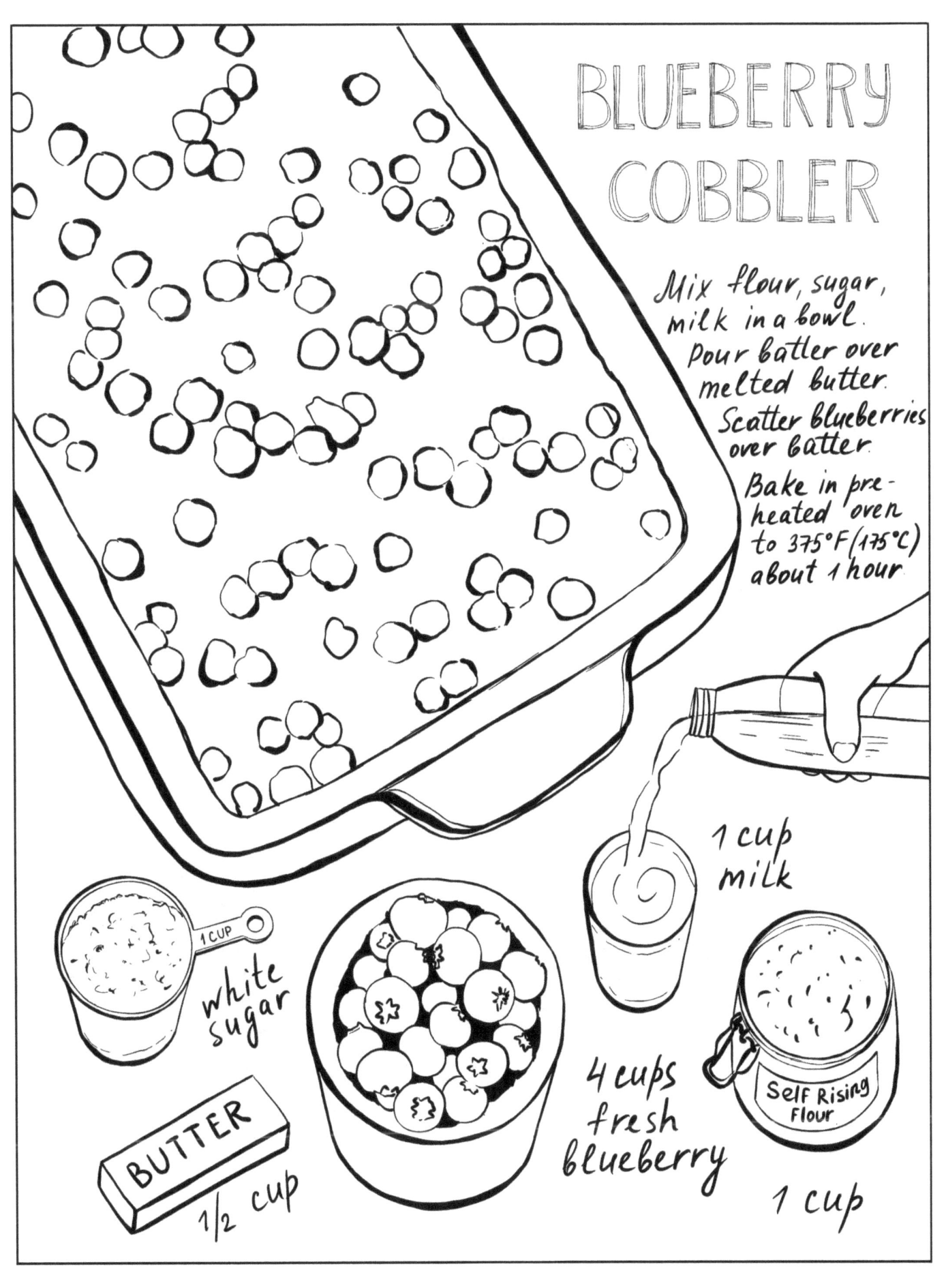

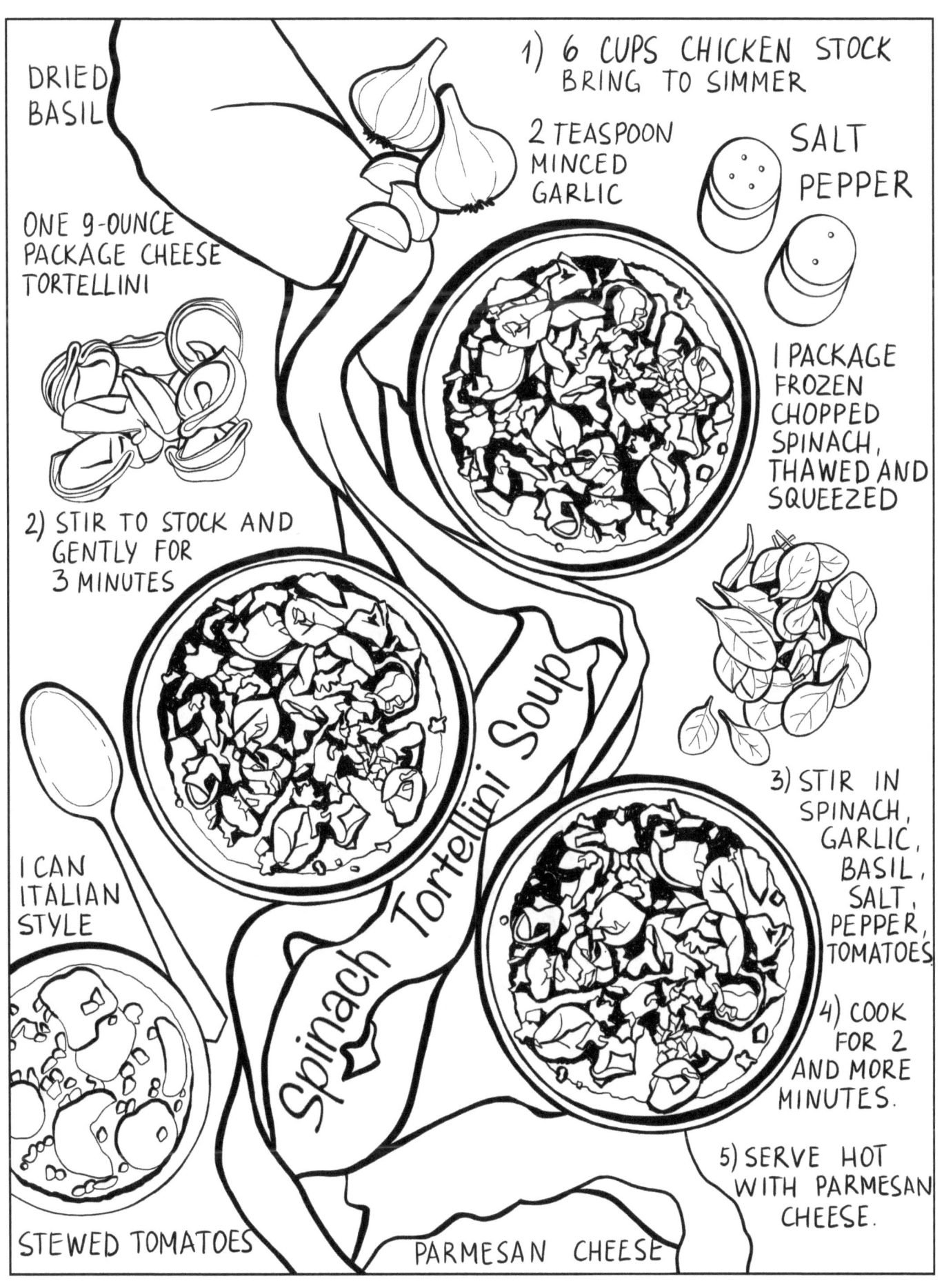

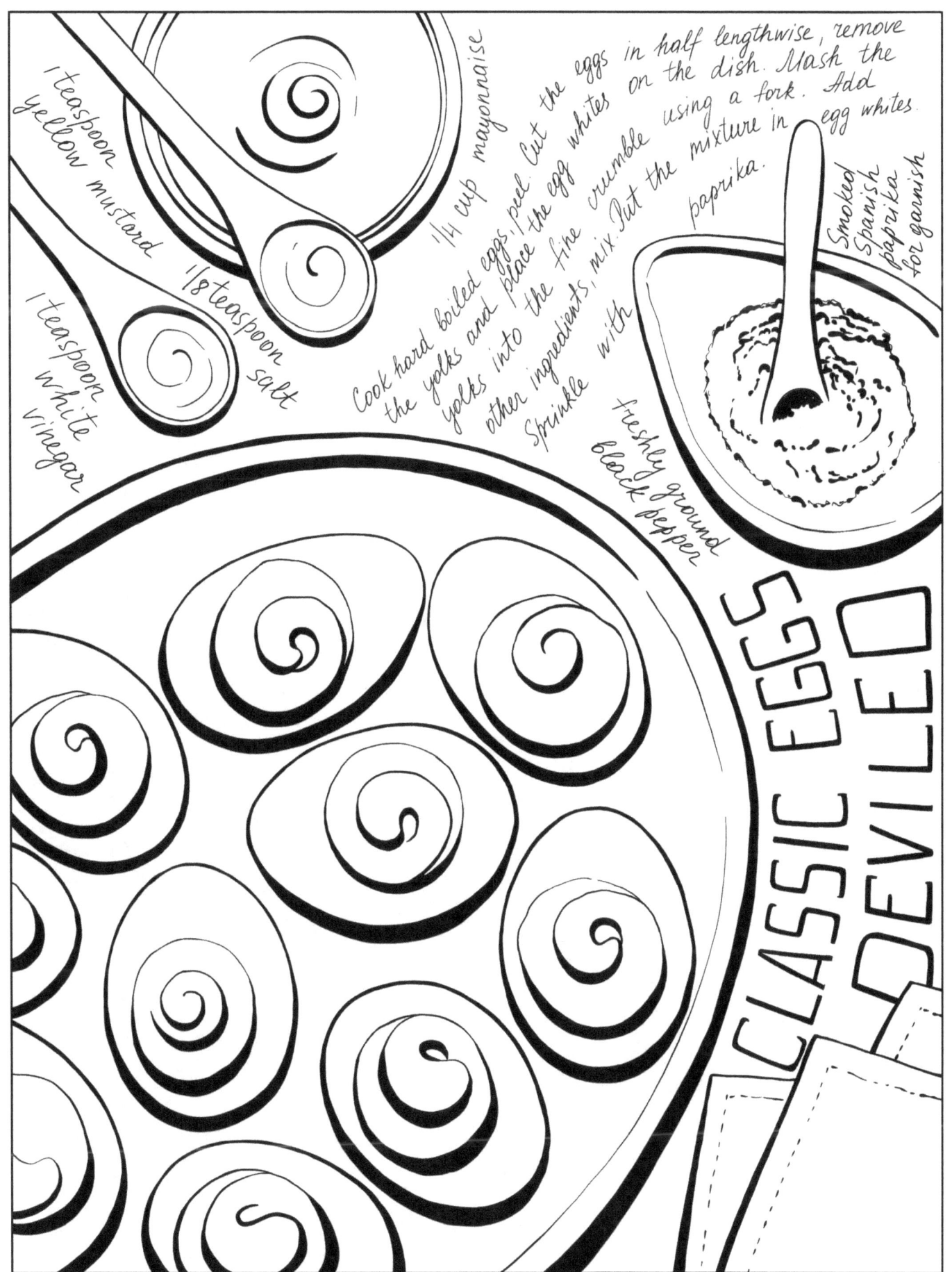

Classic Deviled Eggs

- 1 teaspoon yellow mustard
- 1/8 teaspoon salt
- 1 teaspoon white vinegar
- 1/4 cup mayonnaise
- Smoked Spanish paprika for garnish
- freshly ground black pepper

Cook hard boiled eggs, peel. Cut the eggs in half lengthwise, remove the yolks and place the egg whites on the dish. Mash the yolks into the fine crumble using a fork. Add other ingredients, mix. Put the mixture in egg whites. Sprinkle with paprika.

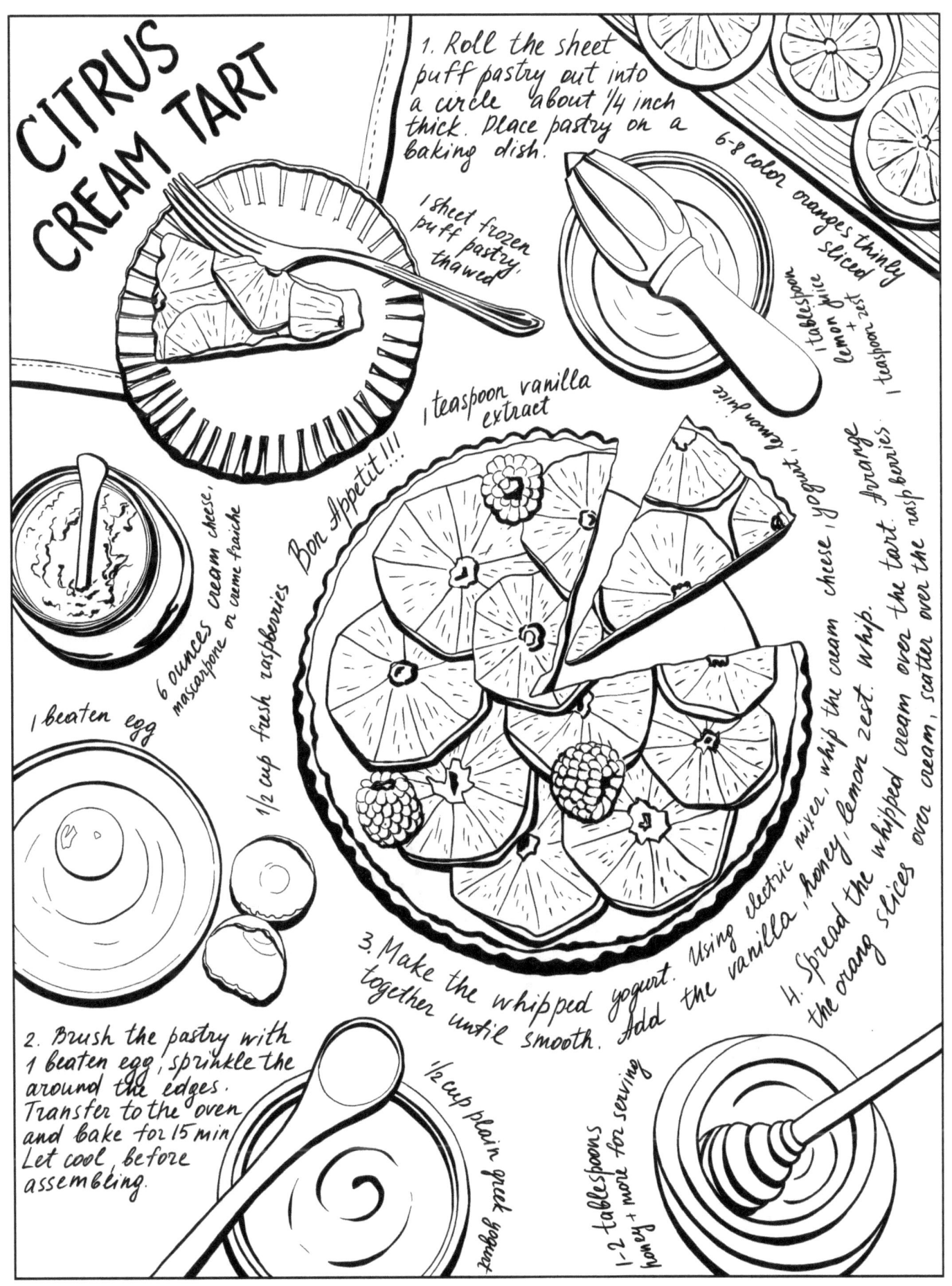

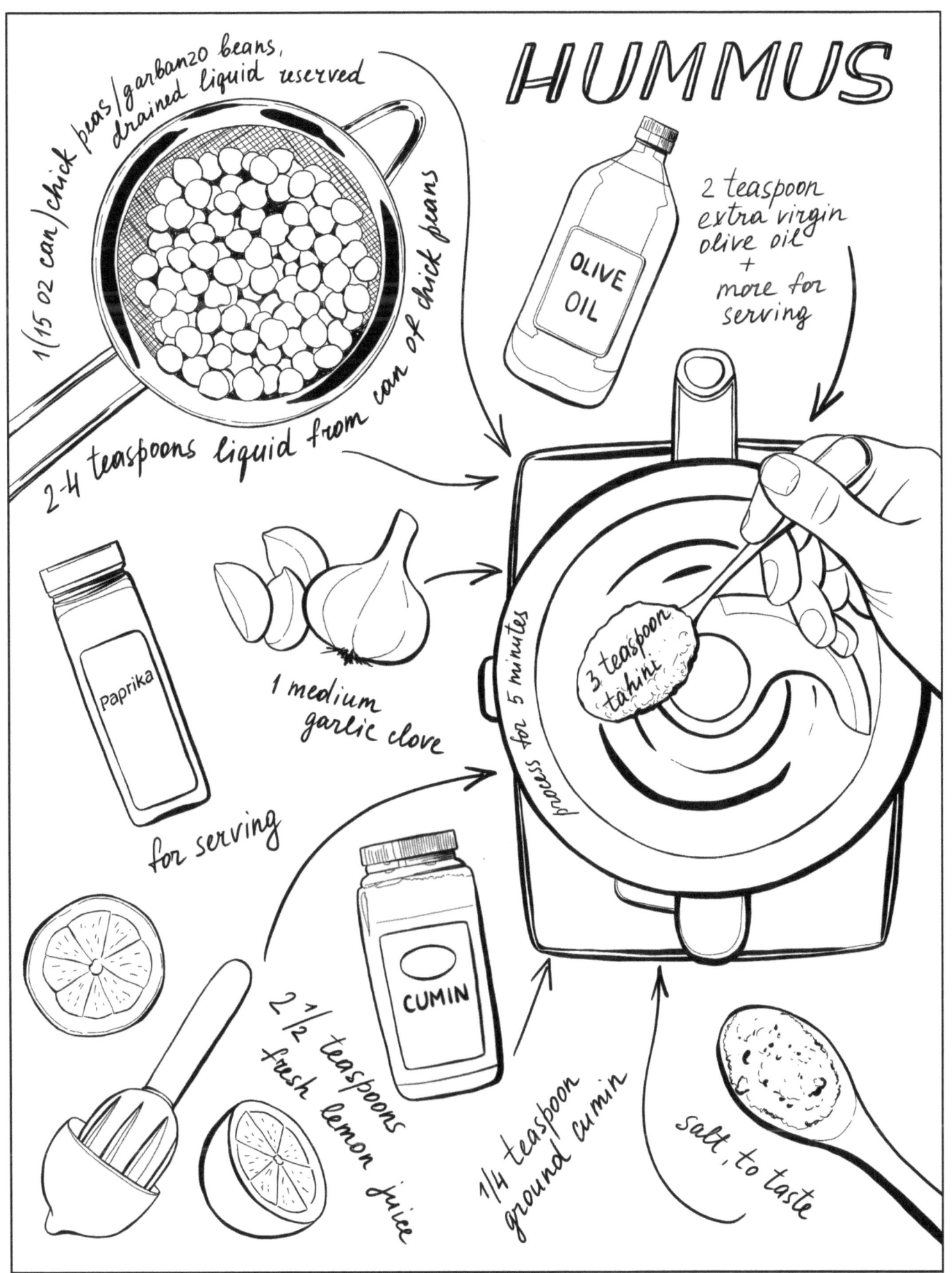

Sangria

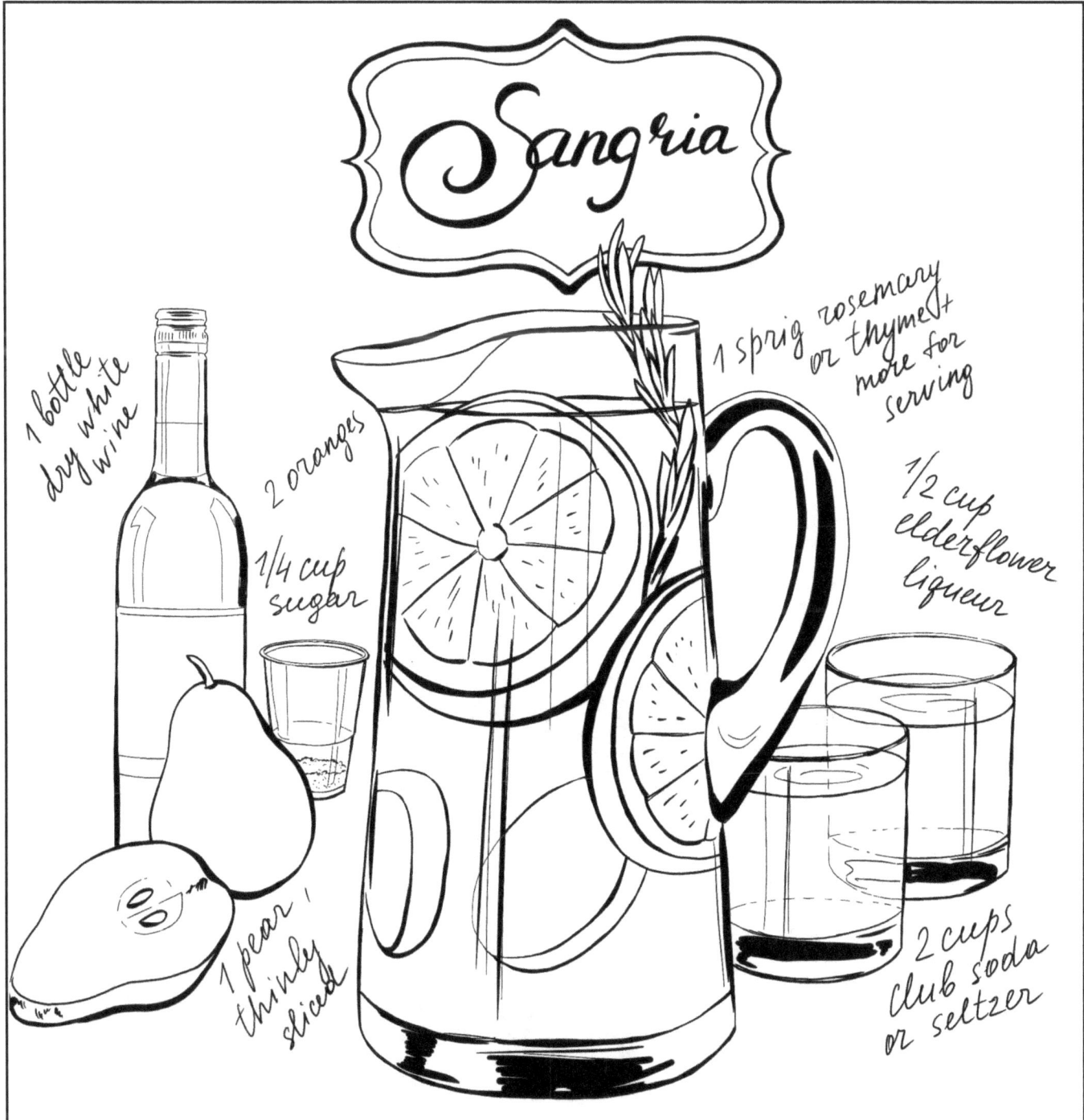

- 1 bottle dry white wine
- 2 oranges
- 1/4 cup sugar
- 1 pear, thinly sliced
- 1 sprig rosemary or thyme + more for serving
- 1/2 cup elderflower liqueur
- 2 cups club soda or seltzer

1. Remove the zest of one orange, cut it in half and squeeze the juice into a jug. Thinly chop the second orange and add to the jug.
2. In a saucepan, bring to a boil the sugar, 1 sprig of rosemary, orange zest and 1/4 cup of water. Remove from heat, cover and let stand for 5 minutes, drain.
3. Add the rosemary simple syrup to the pitcher along with the wine, elderflower liqueur, pear and rosemary sprigs. Mix. Top with club soda before serving. Garnish with rosemary sprigs.

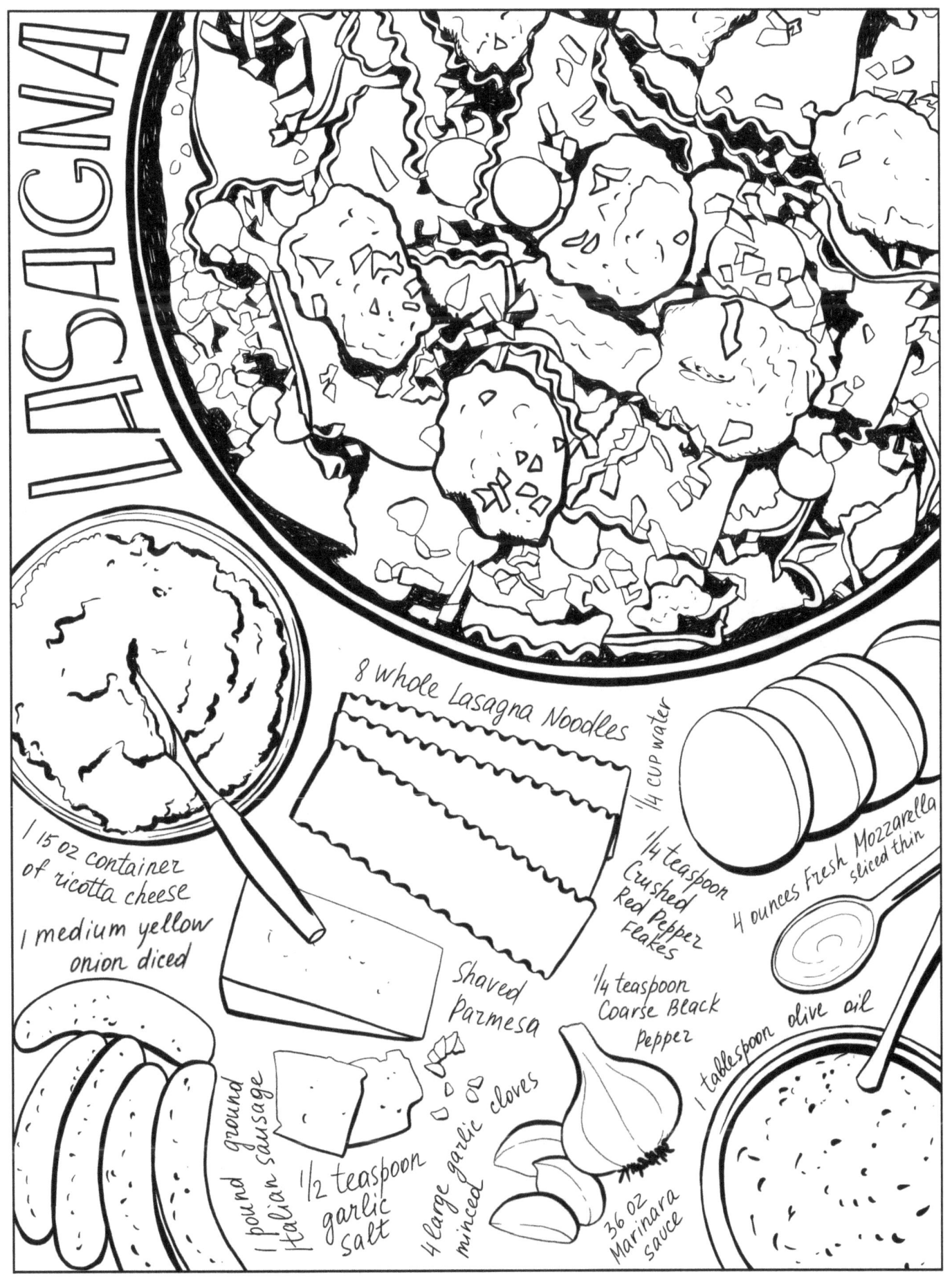

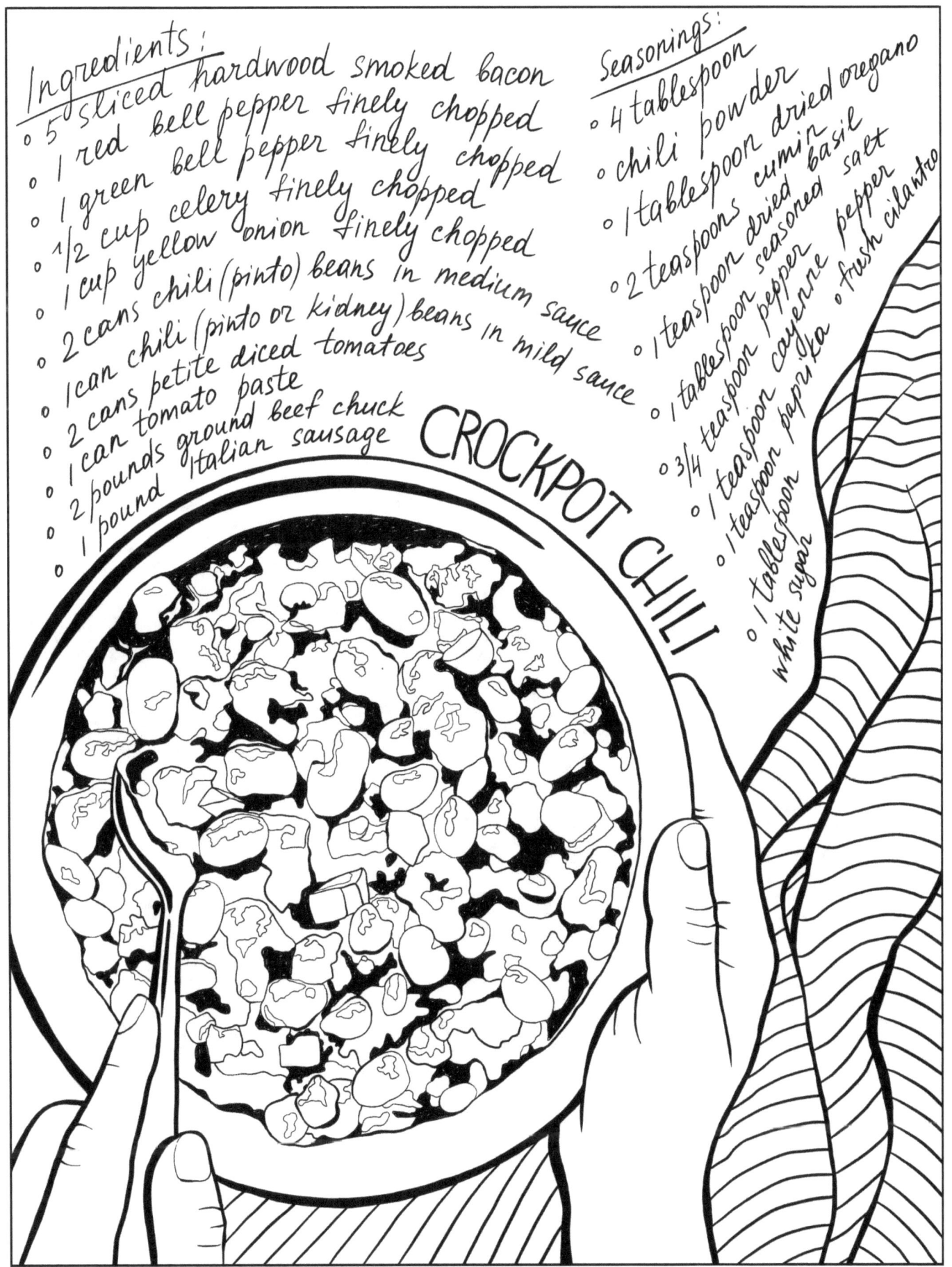

Ingredients:
- 5 sliced hardwood smoked bacon
- 1 red bell pepper finely chopped
- 1 green bell pepper finely chopped
- 1/2 cup celery finely chopped
- 1 cup yellow onion finely chopped
- 2 cans chili (pinto) beans in medium sauce
- 1 can chili (pinto or kidney) beans in mild sauce
- 2 cans petite diced tomatoes
- 1 can tomato paste
- 2 pounds ground beef chuck
- 1 pound Italian sausage

Seasonings:
- 4 tablespoon chili powder
- 1 tablespoon dried oregano
- 2 teaspoons cumin
- 1 teaspoon dried basil
- 1 teaspoon seasoned salt
- 1 tablespoon pepper
- 3/4 teaspoon cayenne pepper
- 1 teaspoon paprika
- 1 tablespoon white sugar
- fresh cilantro

CROCKPOT CHILI

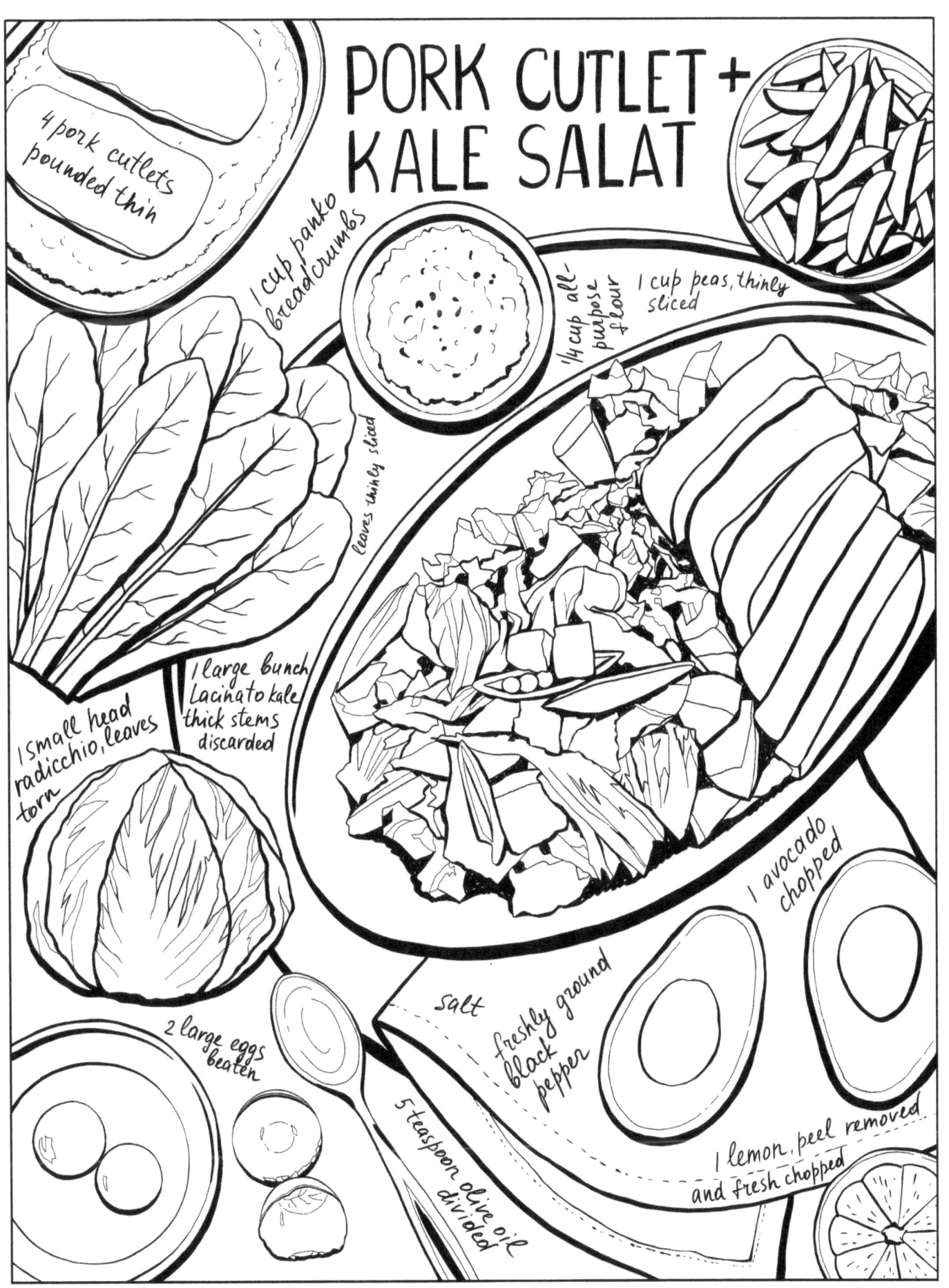

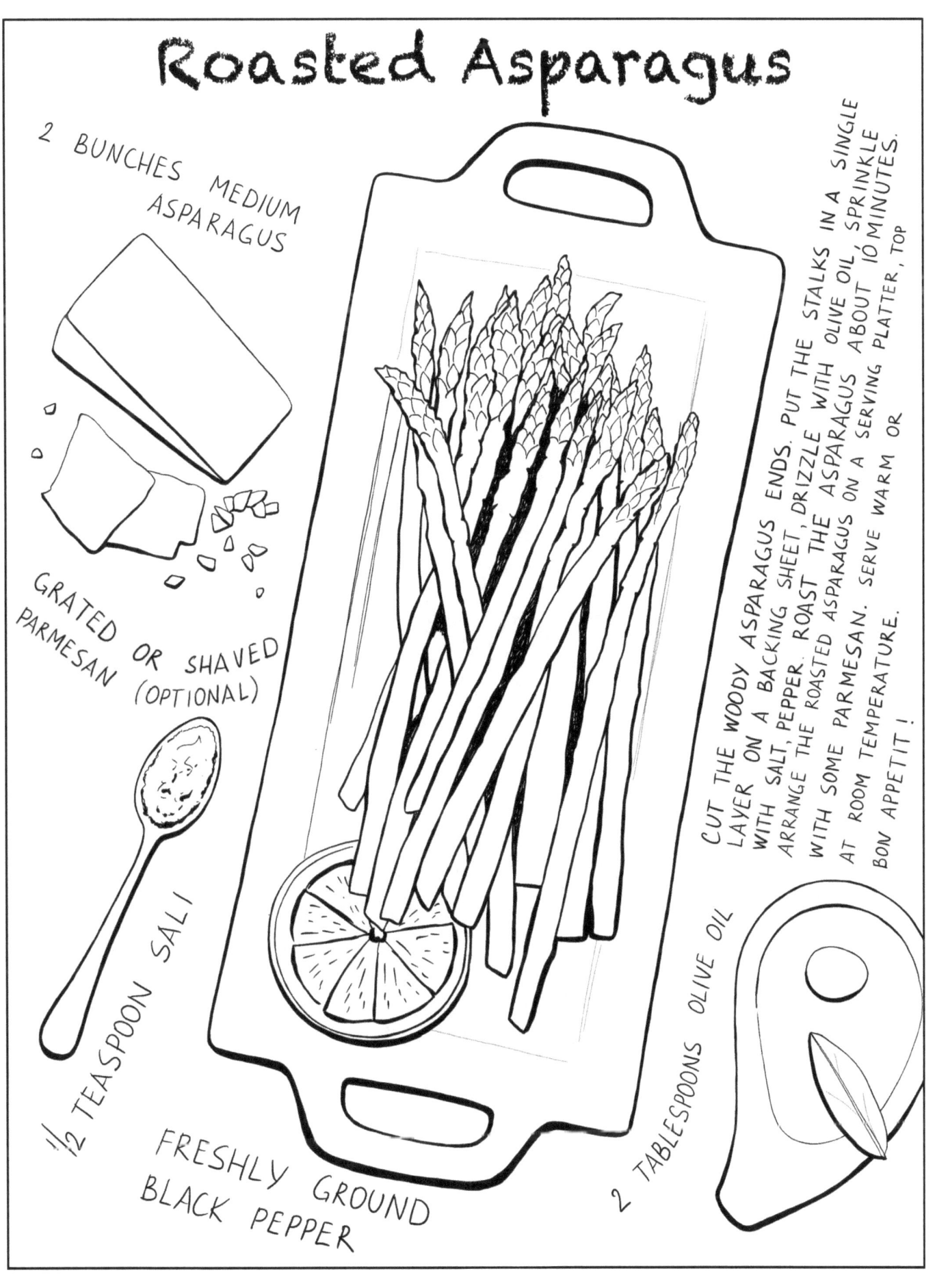

Roasted Asparagus

- 2 bunches medium asparagus
- Grated or shaved parmesan (optional)
- 1/2 teaspoon salt
- Freshly ground black pepper
- 2 tablespoons olive oil

Cut the woody asparagus ends. Put the stalks in a single layer on a baking sheet, drizzle with olive oil, sprinkle with salt, pepper. Roast the asparagus about 10 minutes. Arrange the roasted asparagus on a serving platter, top with some parmesan. Serve warm or at room temperature. Bon appétit!

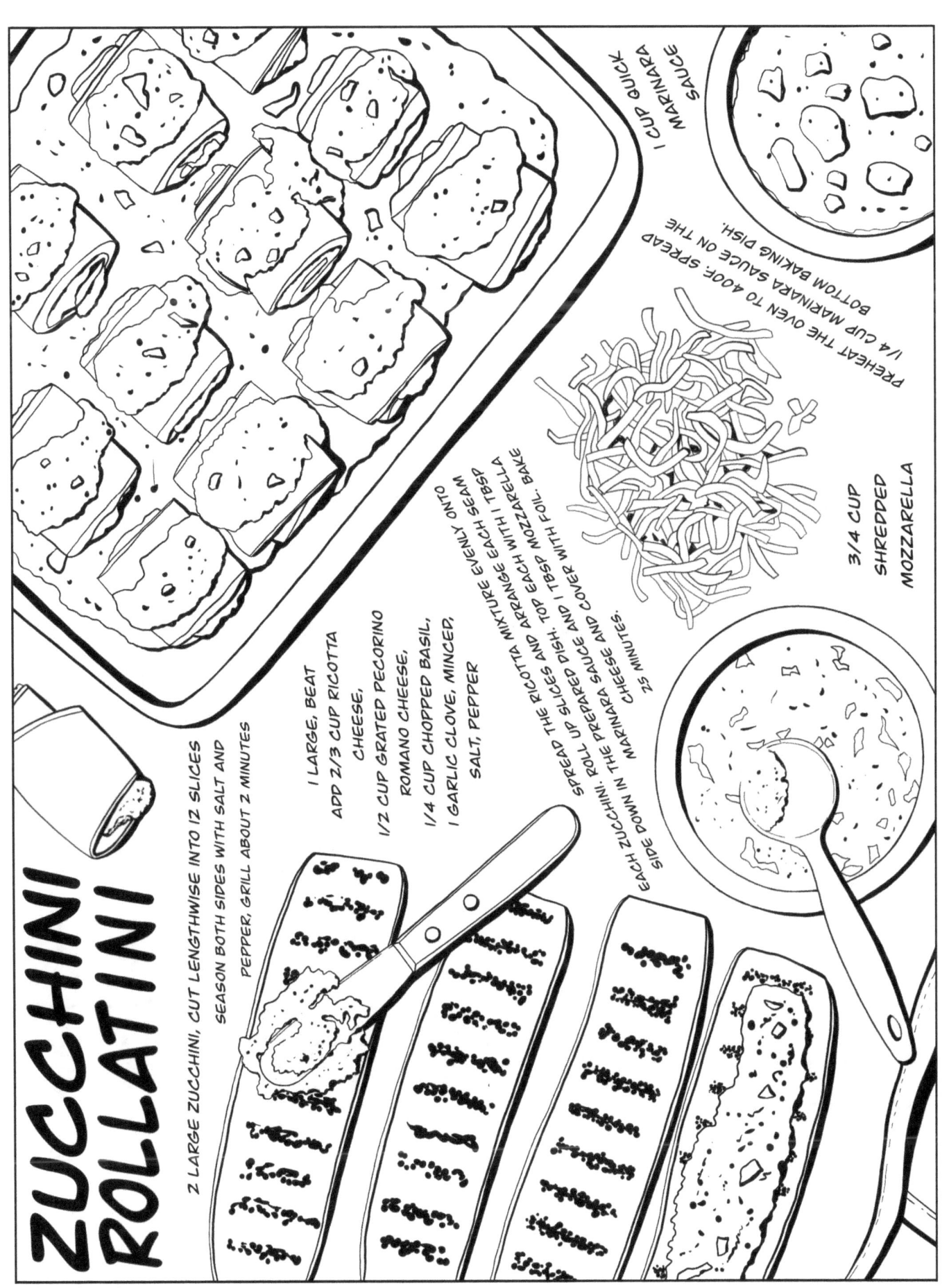

ZUCCHINI ROLLATINI

2 LARGE ZUCCHINI, CUT LENGTHWISE INTO 12 SLICES SEASON BOTH SIDES WITH SALT AND PEPPER, GRILL ABOUT 2 MINUTES

1 LARGE, BEAT
ADD 2/3 CUP RICOTTA CHEESE,
1/2 CUP GRATED PECORINO ROMANO CHEESE,
1/4 CUP CHOPPED BASIL,
1 GARLIC CLOVE, MINCED,
SALT, PEPPER

SPREAD THE RICOTTA MIXTURE EVENLY ONTO EACH ZUCCHINI. ROLL UP SLICES AND ARRANGE EACH SEAM SIDE DOWN IN THE PREPARED DISH. TOP EACH WITH 1 TBSP MARINARA SAUCE AND 1 TBSP MOZZARELLA. BAKE CHEESE AND COVER WITH FOIL. BAKE 25 MINUTES.

3/4 CUP SHREDDED MOZZARELLA

PREHEAT THE OVEN TO 400F. SPREAD 1/4 CUP MARINARA SAUCE ON THE BOTTOM BAKING DISH.

1 CUP QUICK MARINARA SAUCE

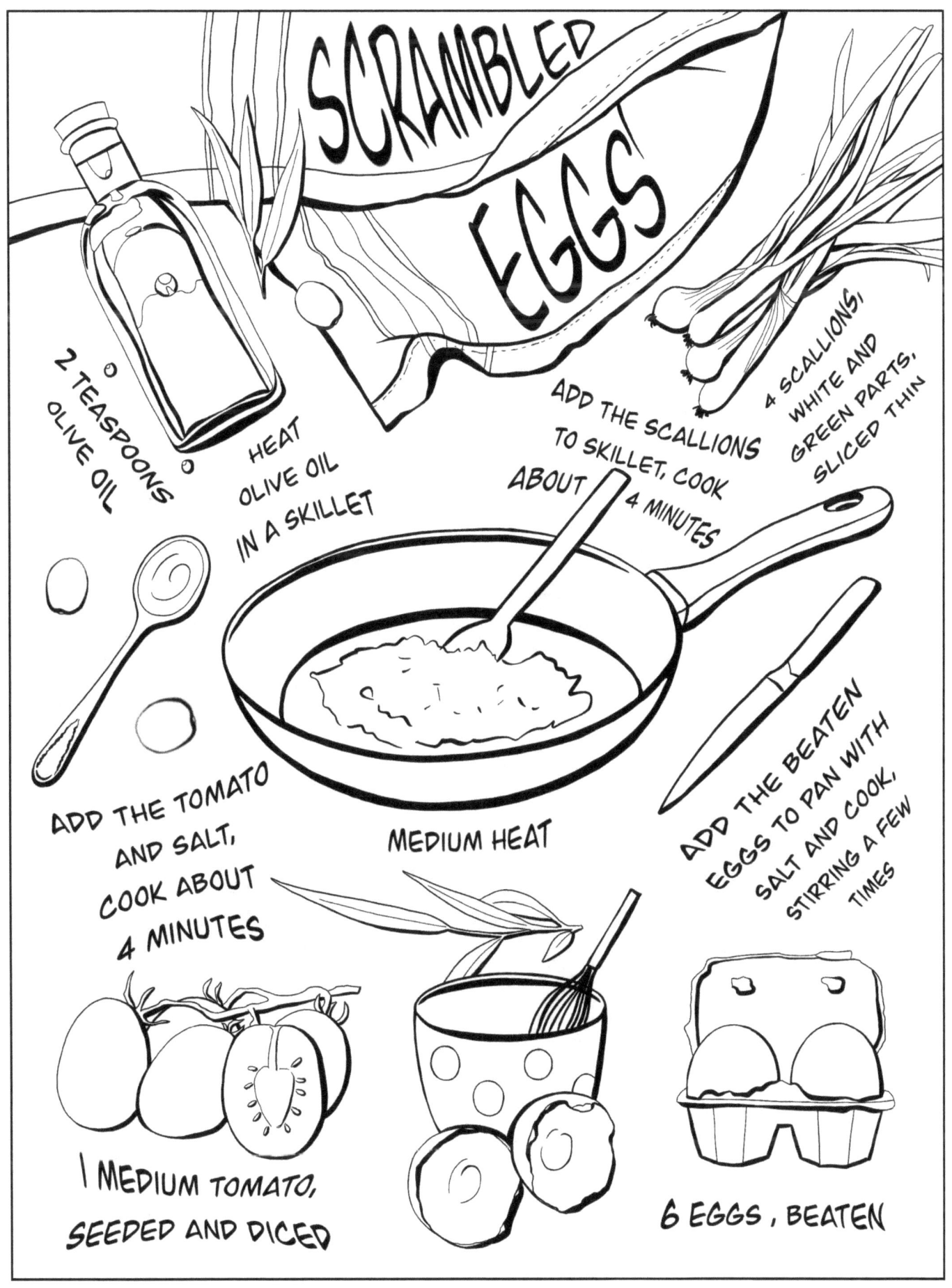

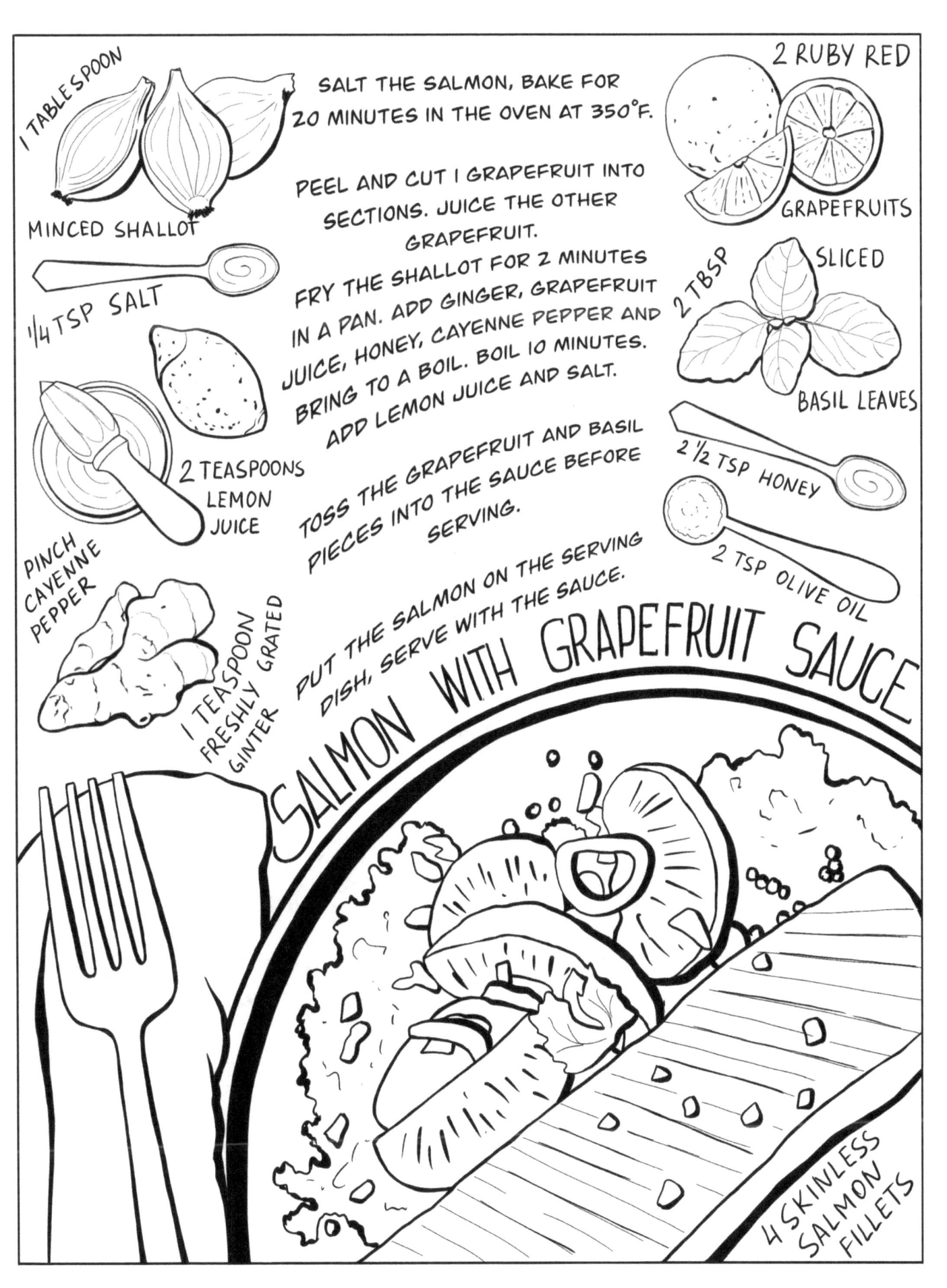

PORK CHOPS + APPLES + BUTTERNUT SQUASH

Ingredients
- 1 SMALL ONION
- YELLOW BUTTERNUT SQUASH
- 3 CUPS BUTTER DIVIDED
- 4 TBSP ITALIAN SEASONING
- 2 TSP SALT + PEPPER
- 4 THICK CUT PORK CHOPS
- 1 TSP FRESH ROSEMARY MINCED
- 2 TBSP BROWN SUGAR
- 1/2 TSP GROUND CINNAMON
- 5 SMALL GARLIC MINCED
- 3/4 CUP SPICED APPLE CIDER OR REGULAR APPLE CIDER
- 2 APPLES CORED AND THINLY SLICED

Instructions

PREPARE THE PORK CHOPS WITH SALT, PEPPER AND ITALIAN SEASONING ON BOTH SIDES. SET ASIDE. MELT 2 TBS BUTTER OF MEDIUM-HIGH HEAT IN A LARGE SKILLET. ADD THE PORK CHOPS, COOK 5-6 MINUTES. TRANSFER PORK CHOPS TO A PLATE AND SET ASIDE.

TO THE SAME SKILLET ADD 1 TBS BUTTER AND THE BUTTERNUT SQUASH FOR 5 MINUTES. ADD THE ONION AND CONTINUE TO COOK UNTIL ONION TURNS TRANSLUCENT 3-5 MINUTES. ONCE THE BUTTERNUT SQUASH JUST STARTS TO SOFTEN AND THE ONIONS ARE TRANSLUCENT, ADD THE MINCED GARLIC, FRESH ROSEMARY, BROWN SUGAR, AND CINNAMON TO THE BUTTERNUT SQUASH. MIX WELL TO COMBINE. COOK FOR 1-2 MINUTES. ADD THE SPICED APPLE CIDER AND APPLES. MIX. RETURN THE PORK CHOPS TO THE SKILLET. COOK 3-4 MINUTES.

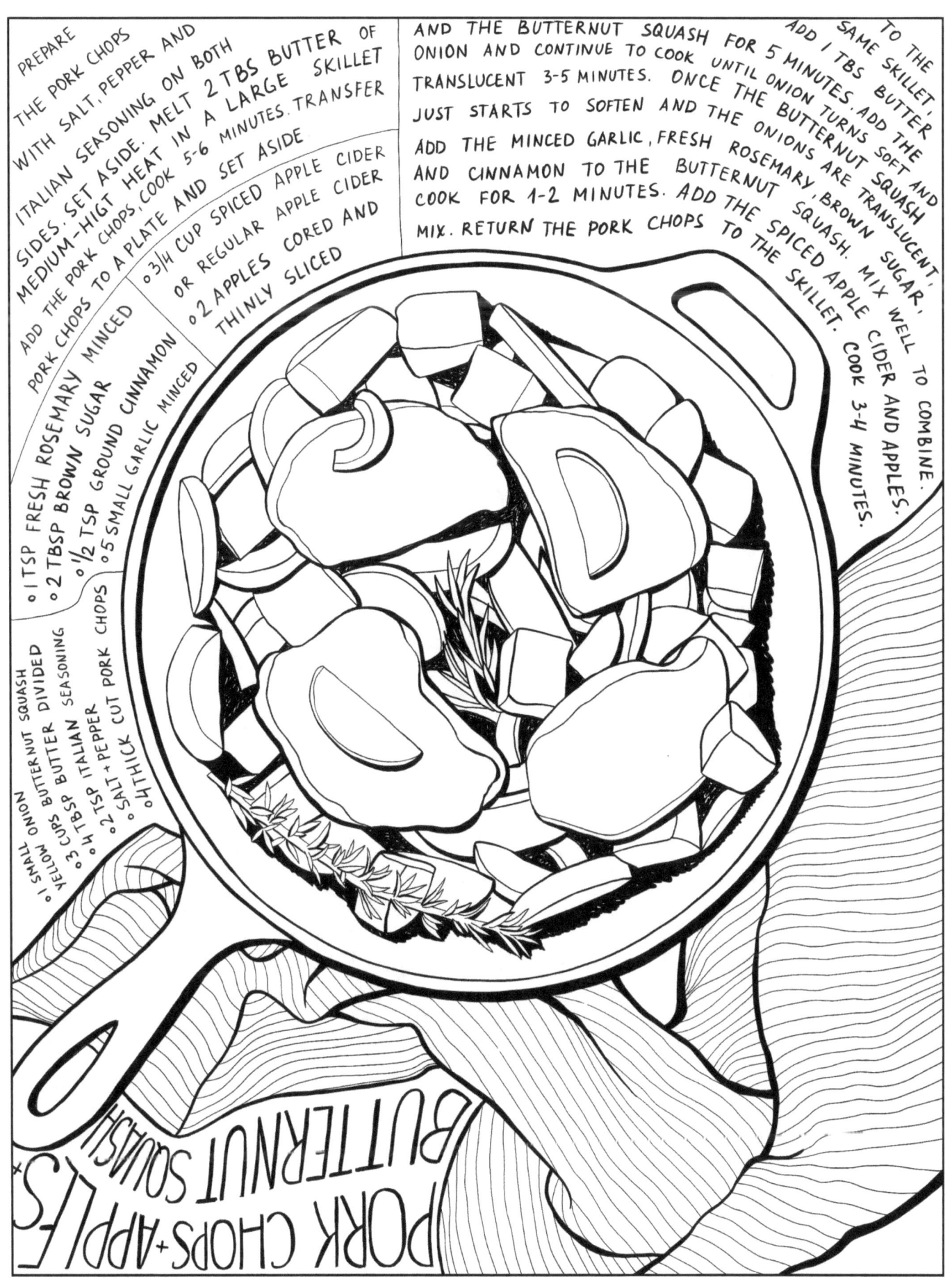

HONEY CARROTS

- 1 POUND BABY CARROTS
- 2 TABLESPOONS BUTTER
- 2 TABLESPOONS HONEY
- 1 TABLESPOON LEMON JUICE
- SALT
- FRESHLY GROUND BLACK PEPPER
- 1/4 CUP CHOPPED FLAT-LEAF PARSLEY

COOK THE BABY CARROTS IN SALTED WATER FOR 5 MINUTES. DRAIN THE CARROTS, ADD TO THE PAN WITH BUTTER, HONEY, LEMON JUICE. COOK FOR 5 MINUTES. SEASON WITH SALT, PEPPER AND ADD PARSLEY.

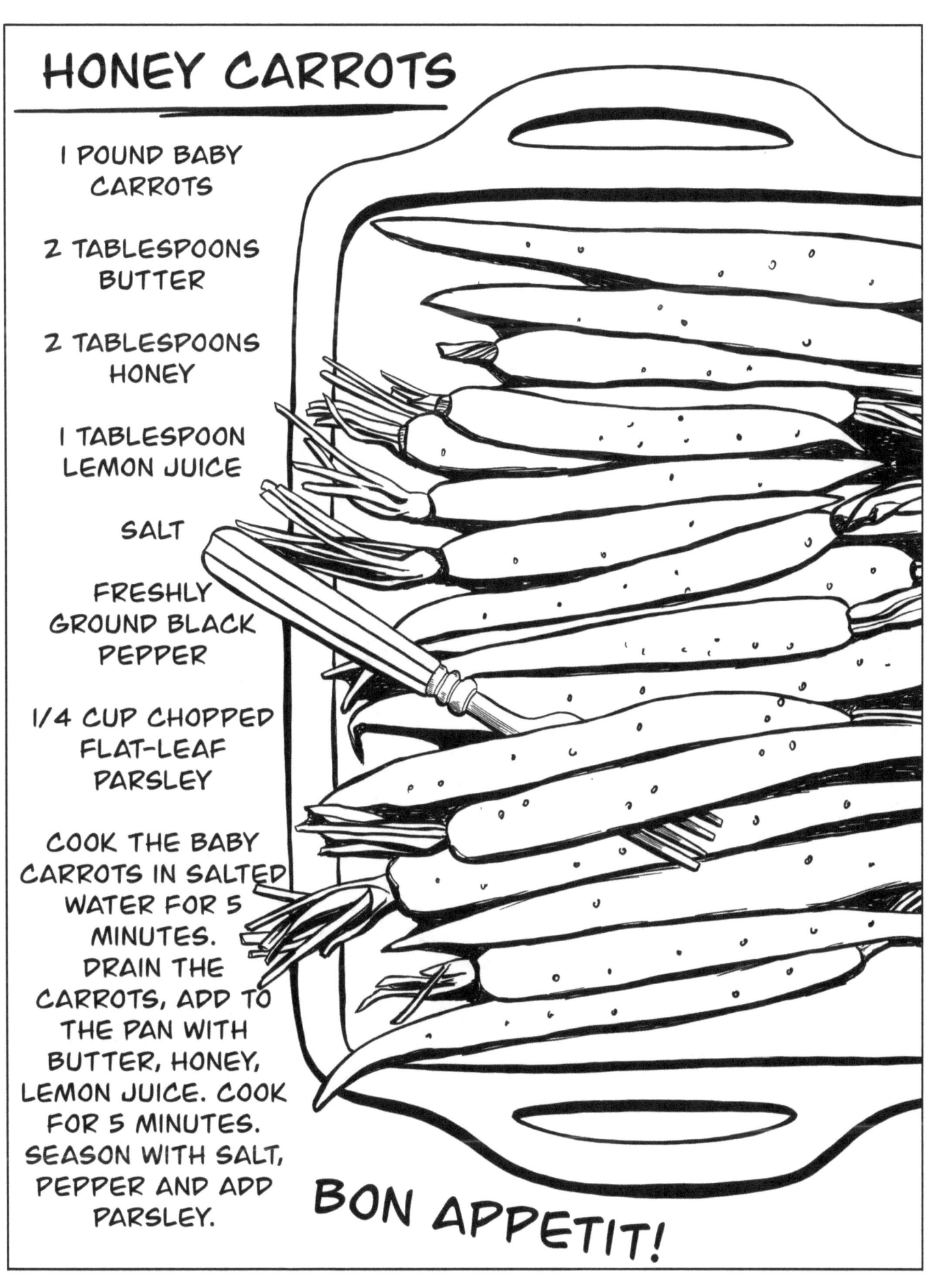

BON APPETIT!

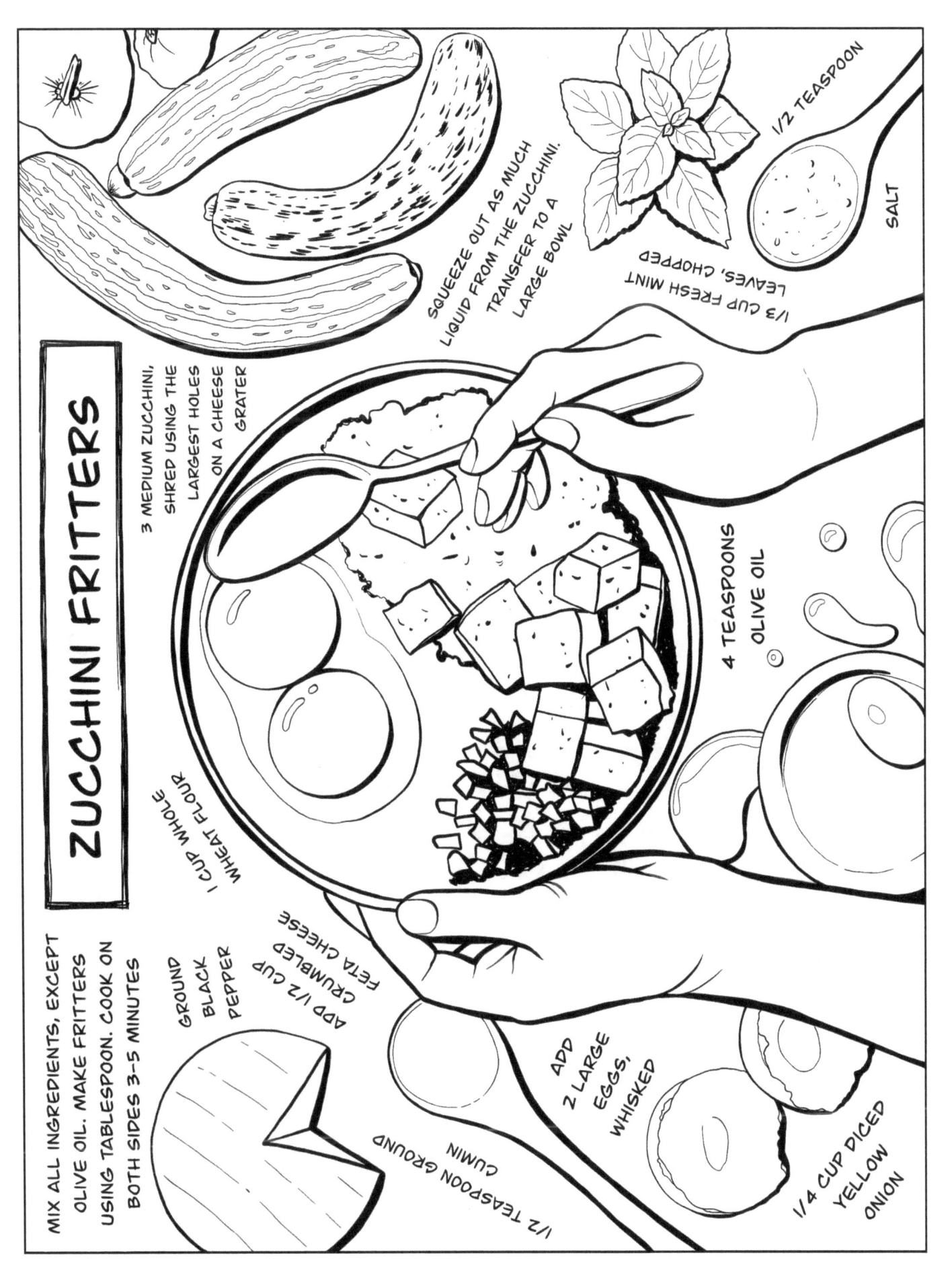

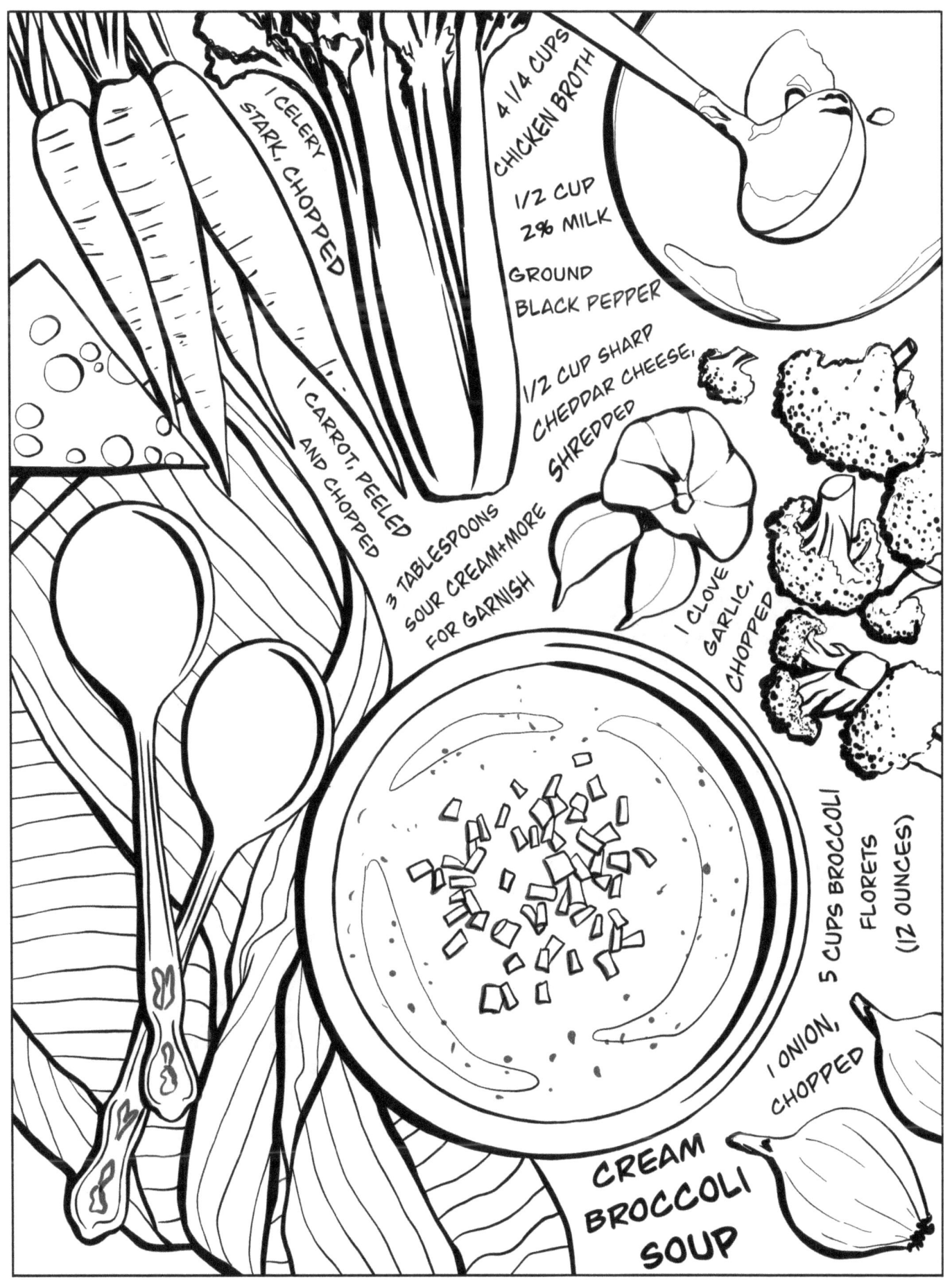

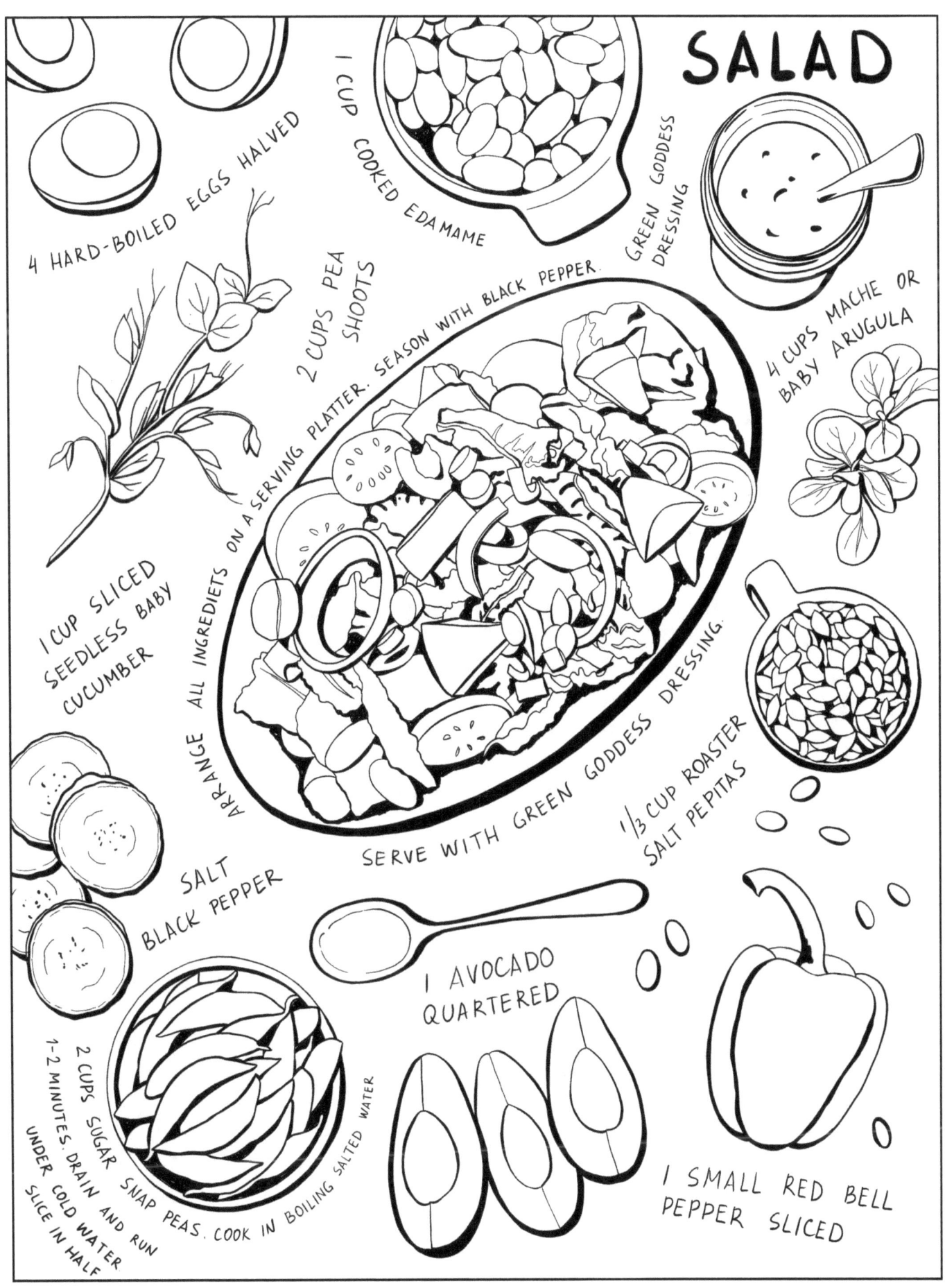

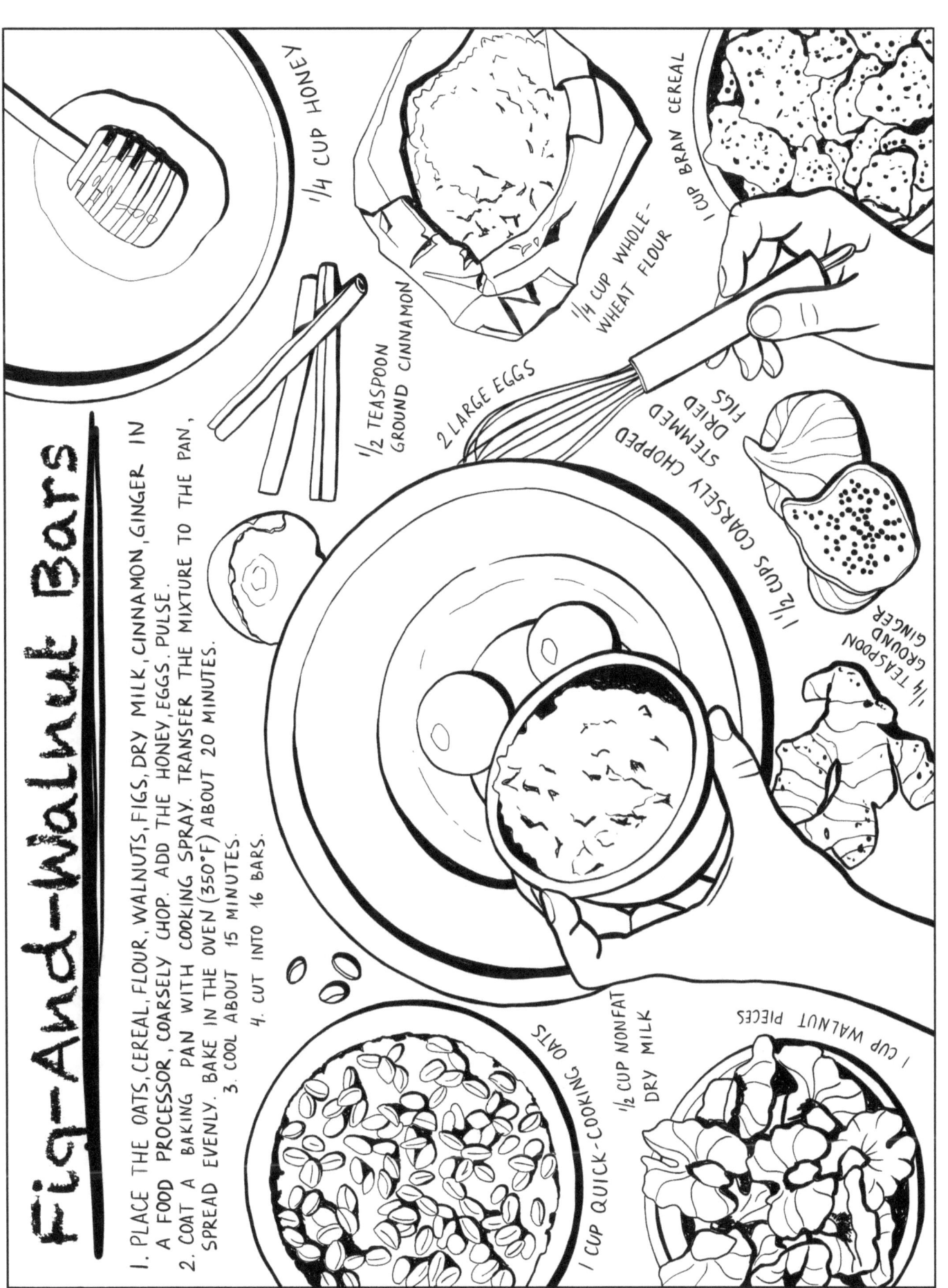

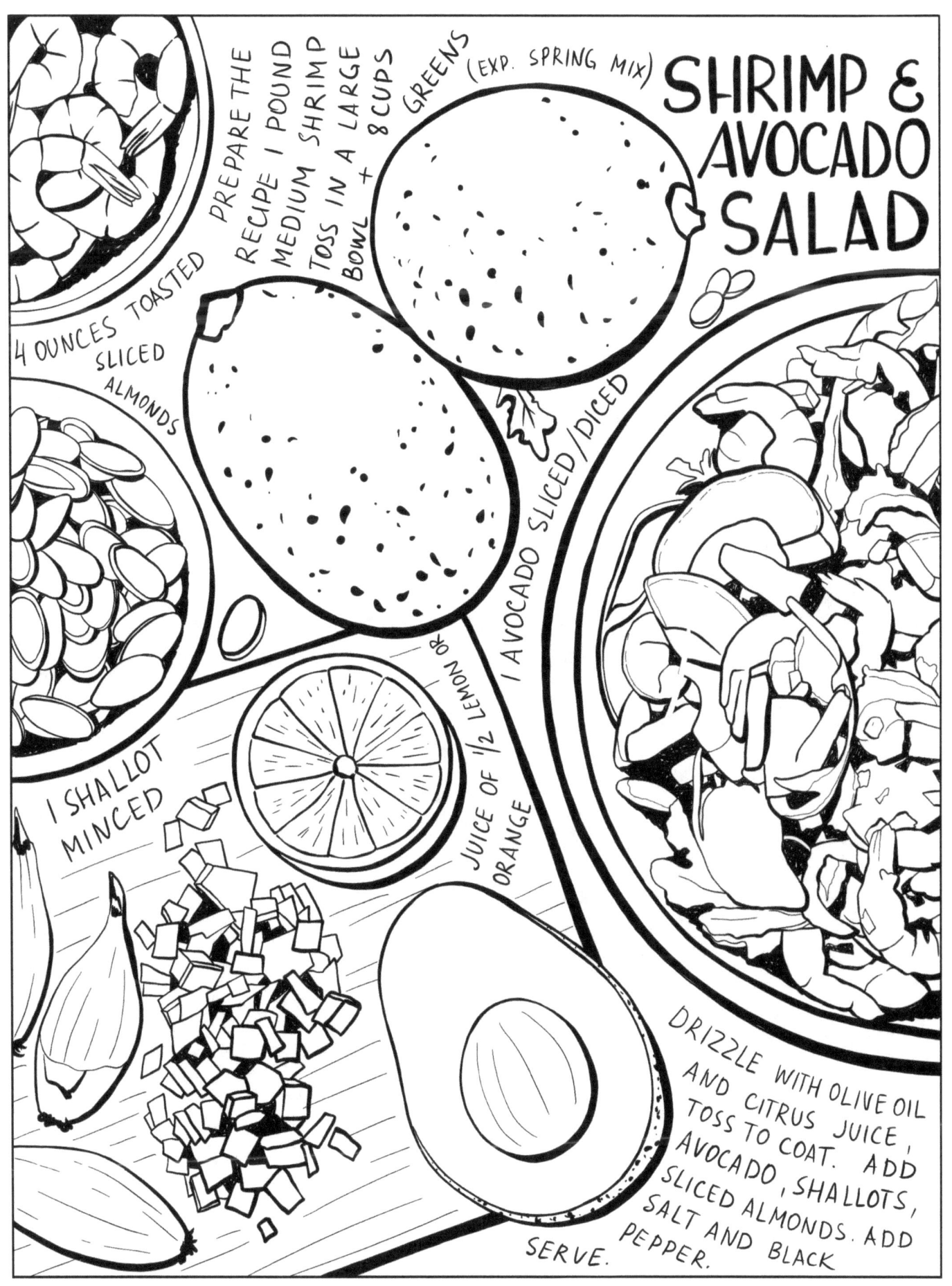

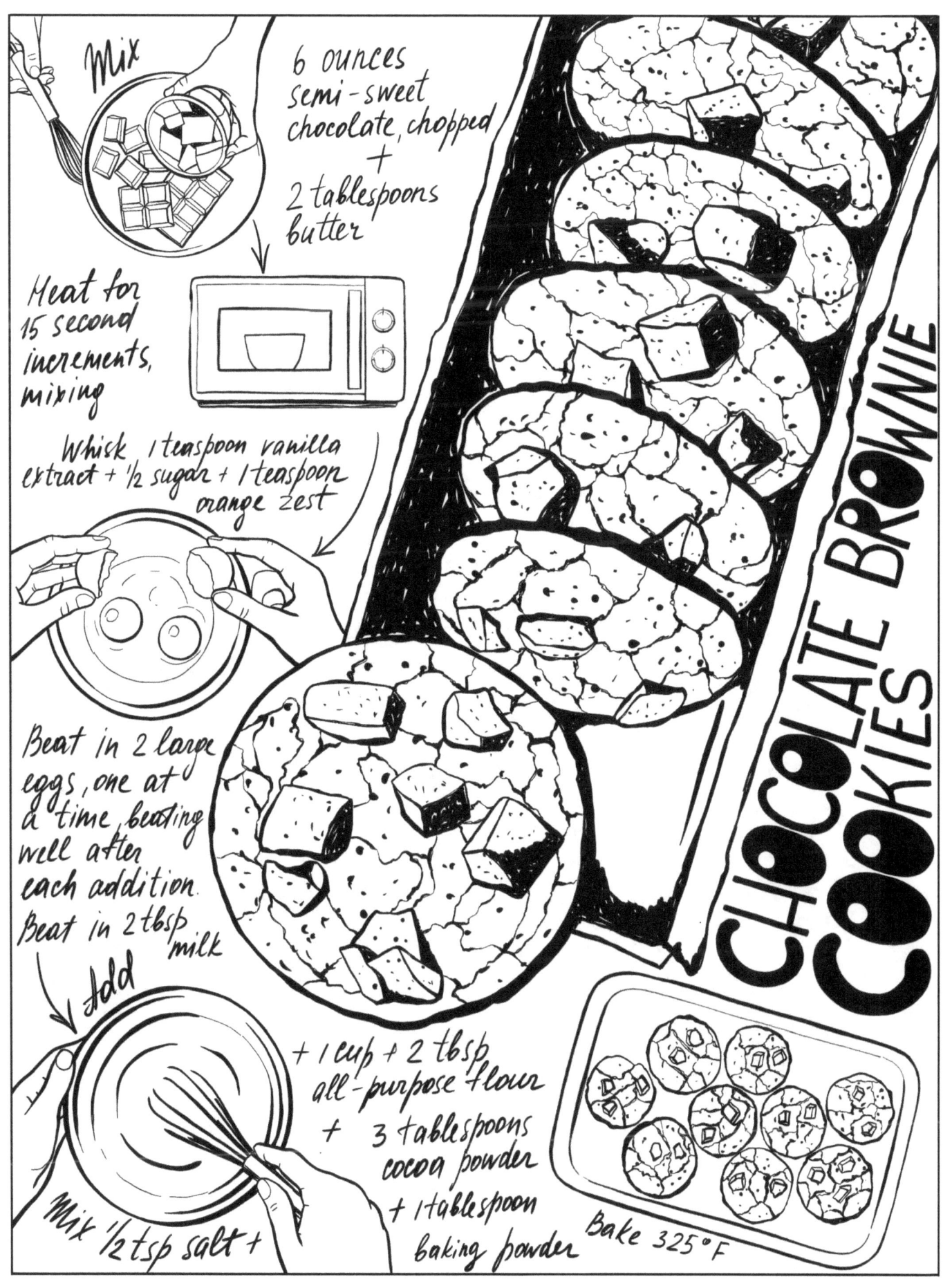

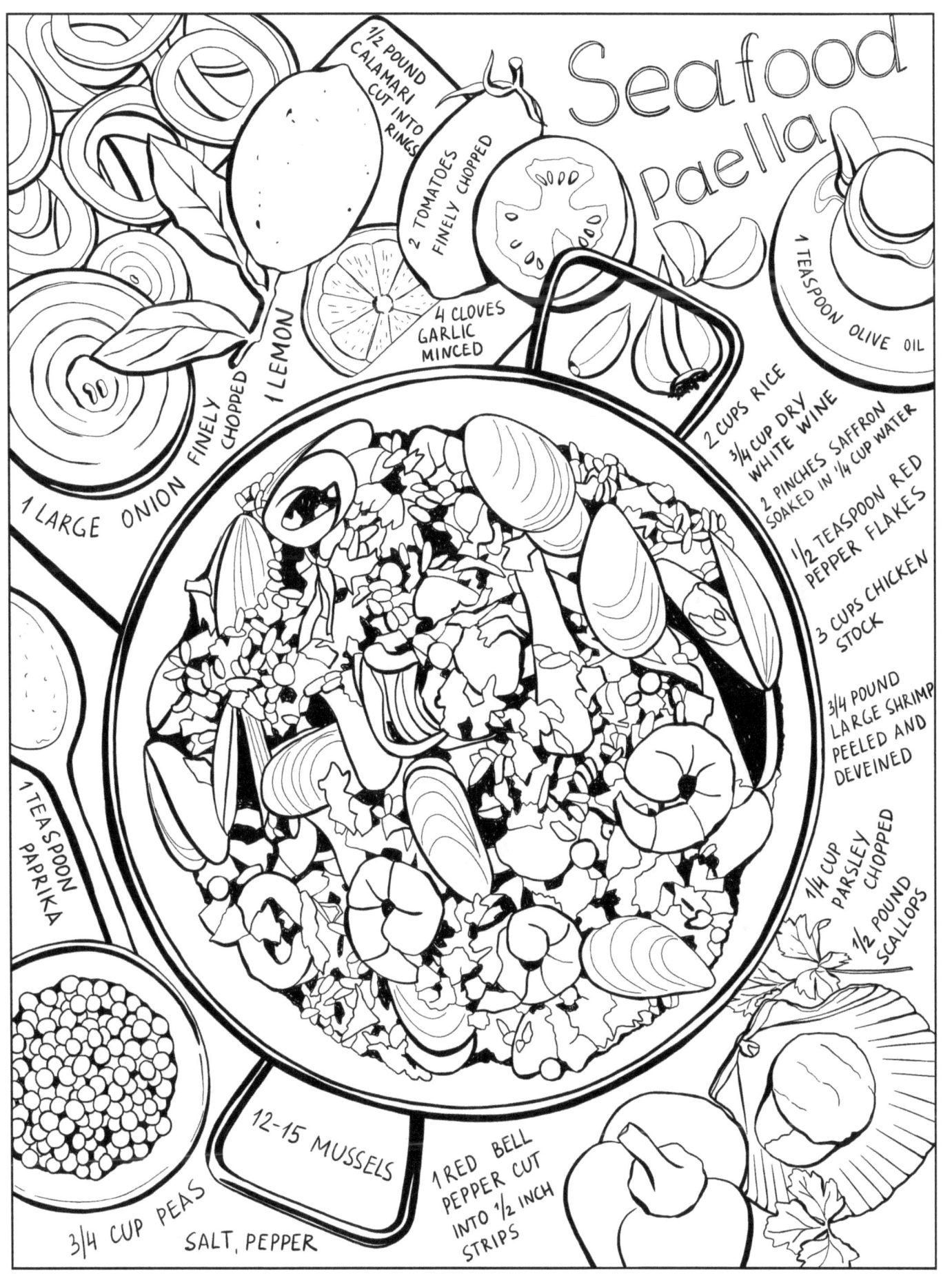

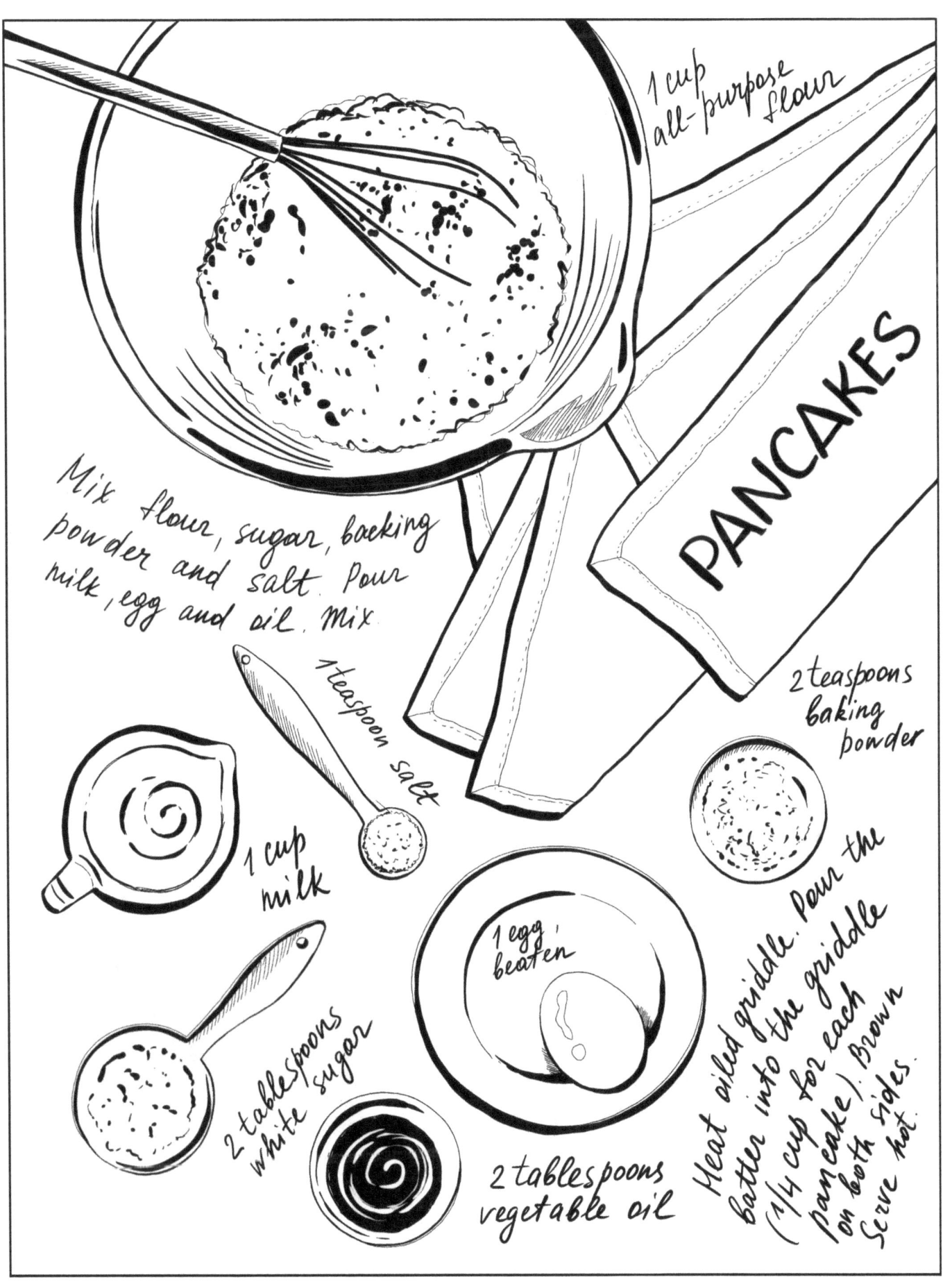

CREAMY GARLIC SALMON

Ingredients:

- 1 tablespoon olive oil
- 21 oz salmon filets skin
- 1 teaspoon garlic powder
- 2 tablespoons butter
- 6 cloves garlic minced
- 1/2 cup chicken broth
- 1 1/2 cups reduced fat cream
- 1/2 cup fresh grated Parmesan parsley
- Juice of 1/2 lemon
- Salt and pepper

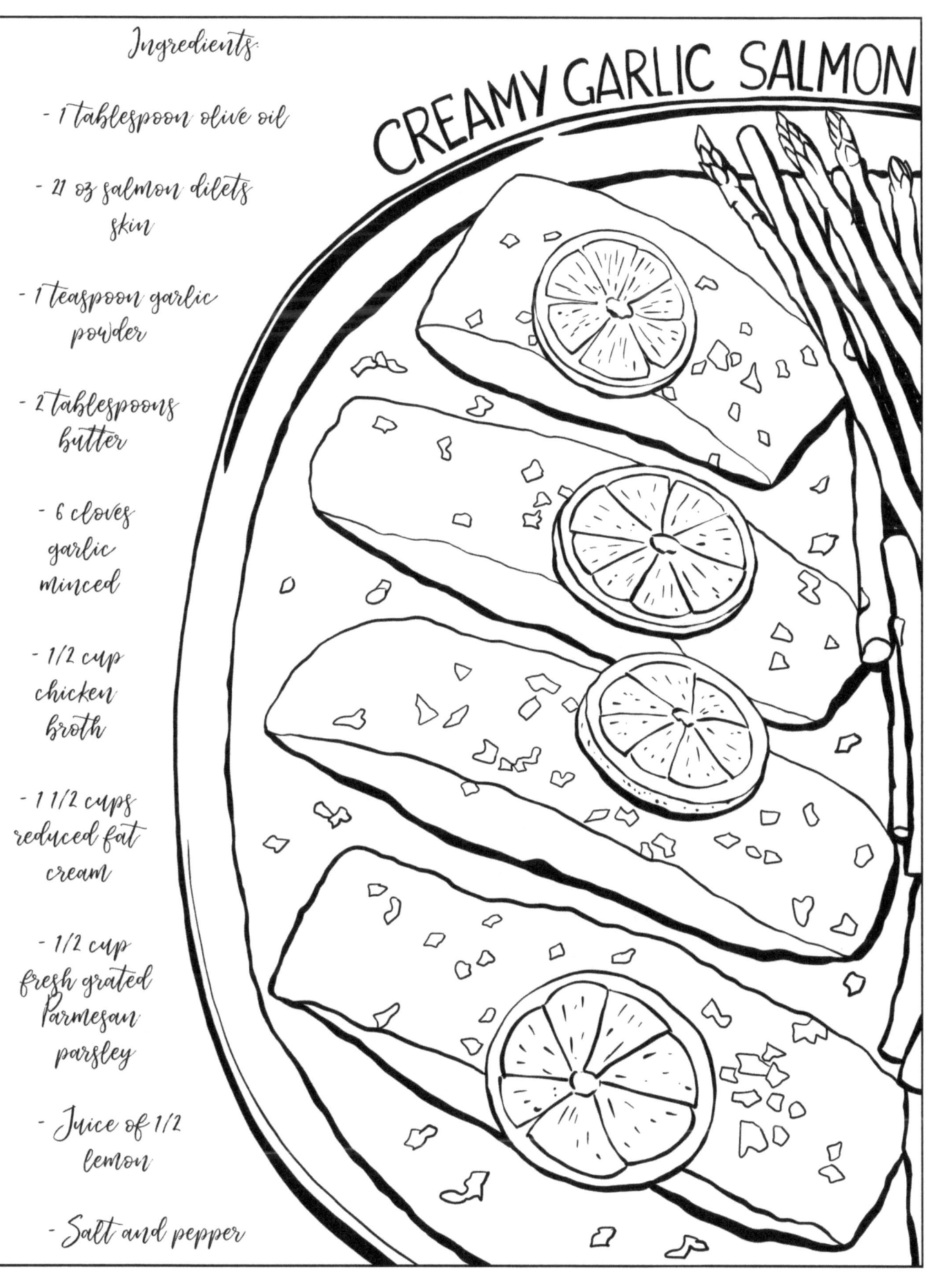

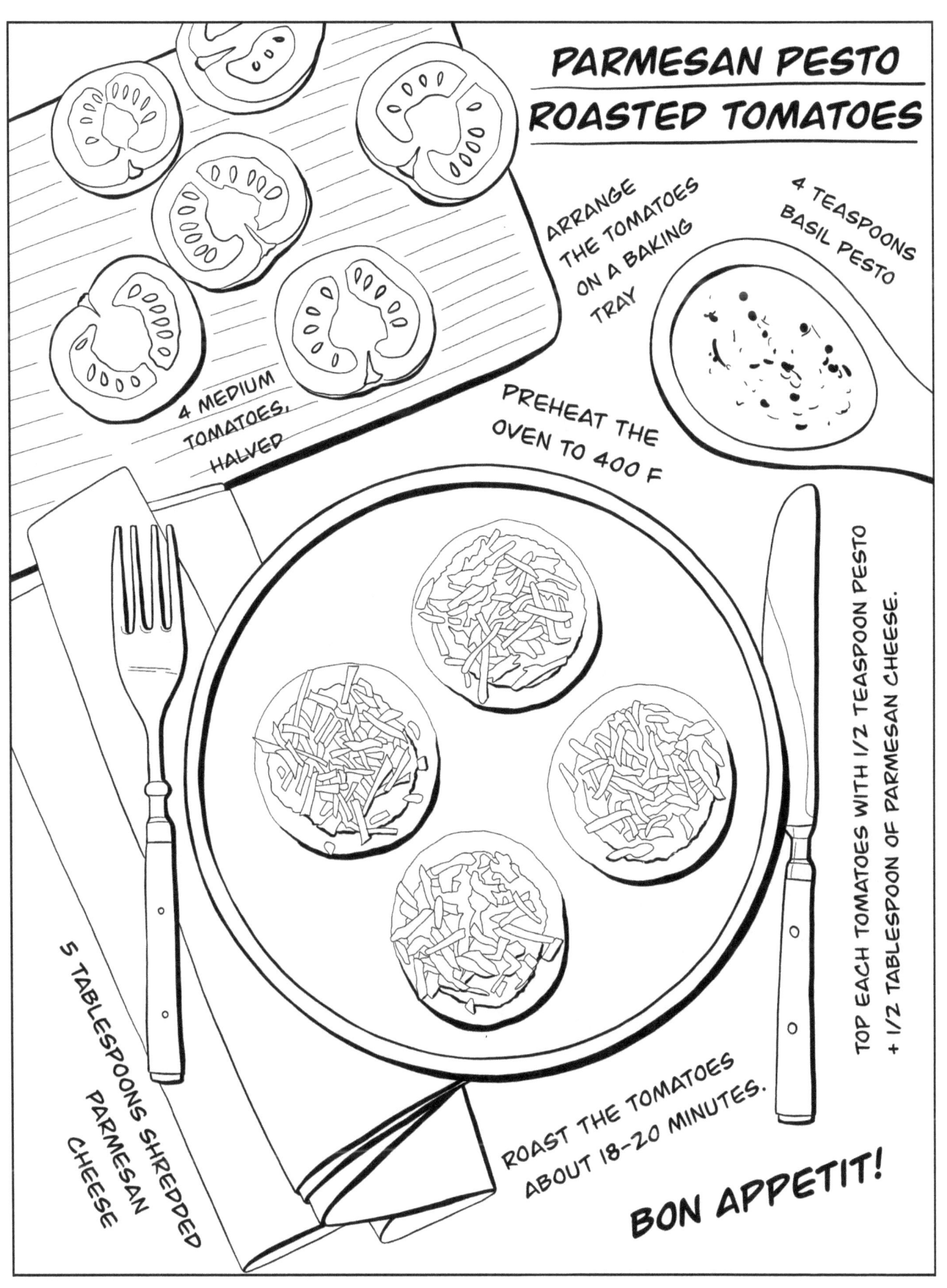

So, here is the end of the food coloring book for adults. Thank you for buying my book. I sincerely hope you found a useful and interesting recipe, enjoyed the coloring and cooking. Loved this book? Let the world know!

Reviews are the lifeblood of independent authors. If you enjoyed your creative journey through these pages, please share your experience (and maybe even a photo of your finished work!) on Amazon.
Thank you for supporting my art!

Viktoriya Yakubouskaya

Copyright 2019 ReStyleGraphic. All Right Reserved

No part of this book may be reproduced or transmitted in any form or by any means, electronic or mechanical, including photocopying, recording or by any information storage and retrieval system, without written permission from the publisher.

The information provided within this book is for general informational purposes only. While we try to keep the information up-to-date and correct, there are no representations or warranties, express or implied, about the completeness, accuracy, reliability, suitability or availability with respect to the information, products, services, or related graphics contained in this book for any purpose.

Have a question? Let us know to **yaviki@yahoo.com**

www.ingramcontent.com/pod-product-compliance
Lightning Source LLC
Chambersburg PA
CBHW080948170526
45158CB00008B/2412